FITZWILLIAM MUSEUM
HANDBOOKS

SAMPLERS

This lavishly illustrated book brings together a selection of English and Continental samplers of outstanding quality and interest. The selection includes examples from the fifteenth century to the twentieth, showing the development of techniques and changing fashions in design. It brings to life the many social ramifications of the sampler's manufacture and decoration, from providing an early 'cv' to illustrating the accomplishments of young ladies of leisure. The introduction and full descriptions explain their significance, style, and materials, and all examples are shown in full colour.

FITZWILLIAM MUSEUM HANDBOOKS

SAMPLERS

CAROL HUMPHREY

FITZWILLIAM MUSEUM

PHOTOGRAPHY BY ANDREW MORRIS

CAMBRIDGE
UNIVERSITY PRESS

Published by the Press Syndicate of the University of Cambridge
The Pitt Building, Trumpington Street, Cambridge CB2 1RP
40 West 20th Street, New York, NY 10011-4211, USA
10 Stamford Road, Oakleigh, Melbourne 3166, Australia

First published 1997

Printed in the United Kingdom at the University Press, Cambridge

A catalogue record for this book is available from the British Library

Library of Congress cataloguing in publication data
Humphrey, Carol.
Samplers / Carol Humphrey; photography by Andrew Morris.
p. cm. – (Fitzwilliam Museum handbooks)
ISBN 0-521-57300-9 (hardback). – ISBN 0-521-57592-3 (paperback).
1. Samplers–England–Themes, motives. 2. Samplers–Europe–
– Themes, motives. 3. Samplers–England–Cambridge. 4. Fitzwilliam
museum. I. Title. II. series.
NK9143.H86 1997
746.3942'074'42659–dc20 96-2855CIP

ISBN 0 521 57300 9 hardback
ISBN 0 521 57592 3 paperback

TAG

FOR GRACE

CONTENTS

Preface XI

Introduction 1

PREFACE

Samplers have been worked wherever embroidery has enjoyed a sustained popularity as a decorative art. It is only during the last hundred or so years that they have been seriously collected. The many public and private collections which now exist across the world reflect the different priorities that have influenced such acquisitions. Some are particular to a region or country, some more concerned with the quality of decoration and technique, and others are based on chronological historic development.

The Fitzwilliam Museum is fortunate in having received two major bequests reflecting some of this diversity of approach. Almost a third of the illustrated samplers were bequeathed to the museum in 1928 by Dr J. W. L. Glaisher, FRS. Dr Glaisher, a mathematician and Fellow of Trinity College, is best known as a formidable collector of pottery and porcelain. This was to form a major bequest to the Fitzwilliam and was later published in the catalogue by Bernard Rackham. It is perhaps no coincidence that pottery of the pre-industrial age seemed to be Dr Glaisher's major interest, as were the earliest samplers, namely those of the seventeenth century. From the occasional references made to samplers in some of his letters, it is plain that he was particularly interested in dated work and in accumulating as comprehensive a collection as possible of dated samplers spanning that century. He was both wise and fortunate to be collecting at a time when they were not widely sought, and succeeded in acquiring English samplers dating from 1629 (no. 3). This particular sampler was the earliest known dated example until Jane Bostocke's sampler of 1598 was acquired by the Victoria and Albert Museum in 1960.

Mrs Longman's bequest of 1938 not only supplemented Dr Glaisher's collection, but widened its scope. It provides almost half of the illustrations in this book. Mrs Longman was a daughter of Sir Arthur Evans, the renowned archaeologist and collector; her half-sister was Dame Joan Evans, the equally renowned historian and collector. Married into the publishing family of Longman, she did not follow the academic bent of father and sister, but she shared their love of collecting, not antiquities and jewellery, the interests of father and sister, but embroidery and samplers. Her taste was catholic and not as focused on the particular as was Dr Glaisher's. From her notes and letters it is quite clear that her much travelled family and friends were under

strict instructions to 'keep their eyes open' wherever they were, hence her acquisition of many Continental samplers often accompanied by notes on provenance and price, the former not necessarily totally accurate.

The combination of the two bequests, the one providing a wealth of dated samplers, mainly English, giving sound chronological evidence of changing styles, and the other including a range of English and Continental samplers that is unusual in a single collection, allows a wider perspective to be taken on the story of the sampler. Those samplers not from the bequests of 1928 and 1938 have been given either individually or in small groups almost invariably by donors fully aware of and wishing to add to the Fitzwilliam's important holding.

<center>❧</center>

I should like to thank Andrew Morris who took all the photographs, and Eleanor Smith for typing the manuscript, as well as the many people who have contributed valuable advice and opinions.

INTRODUCTION

At the end of the twentieth century the story of the sampler is far from over. Surprisingly, at a time when virtually all textiles are mass-produced and women are increasingly employed outside the home, there has been a revival of interest in embroidery. Of course, embroidery can never again be one of the great decorative arts that flourished prior to the Industrial Revolution. Instead a wide spectrum of applications has developed ranging from the realms of mixed media and fibre-arts to simple, commercially produced kits for the adult hobby or leisure market. In the past the domestic embroiderer would have started to learn needle skills at an early age, so that by the time she was in her early teens she could anticipate a lifetime's involvement with the decoration of furnishings, costume, and smaller, more frivolous accessories. The start of this lifetime's work was usually the sampler, a word derived from the Latin 'exemplum' with a meaning that is self-explanatory – an example. Thus the origin of the sampler is utilitarian; it was a means of learning and recording stitches and patterns, a practical *aide-mémoire* before the revolution instigated by the invention of the printing-press and consequent proliferation of printed pattern sheets, books, and magazines. The sampler and historic embroidery fulfilled the decorative demands of their time. Today contemporary embroidery sometimes finds a role amongst the fine arts, but more generally is seen as part of a craft revival. Books, magazines, and kits flood the market with instructions for making 'authentic' samplers, which usually means adapting and simplifying an old design and providing silks or wools of rather bland, pastel colours. Thus the idea of a sampler as a canvas for pattern and stitch variety is totally neglected, and the fact that, in general, bright colours were used on samplers but have simply faded over the years, is ignored. So much for authenticity!

Alongside the craft revival, another facet of the present nostalgia for the past and the growth of the 'heritage industry' is the arrival of the sampler as a tool of the interior decorator. Old samplers have become fashionable furnishing accessories, rescued from attics and corridors and moved in to the destructive light and heat of twentieth-century living areas. The 'picture-shaped' rectangular samplers of the nineteenth century with faded pastel cross stitched motifs arranged around a not too gloomy inscription, were the early favourites. Inevitably it is these that have provided the format for the

bulk of twentieth-century adaptations and reproductions. The stereotyped arrangement of floral border, symmetrically arranged traditional motifs, and perhaps a verse and the maker's name, is easily personalised to today's requirements, which have largely been to make a sampler as a souvenir. The original may have indicated a particular stage in a child's education; its later counterpart is more likely to celebrate a birth or marriage, a coronation or a jubilee. Happily, this fashionable nostalgia for a pastel past not only led to an expanding production of more of the same, but gradually inspired a renewal of interest in the history of the sampler. People began to look at the role of the sampler and the display of the various needle techniques, patterns, and colours which preceded the rather banal output of the last century. Not that a fragile thread of serious interest had not been sustained during the twentieth century. A few important publications and exhibitions had kept alive the appreciation of historic embroidery and samplers.

The Fine Art Society heralded the beginning of the twentieth century with an exhibition of embroidery in 1900 which included many samplers and inspired the publication of Marcus Huish's book *Samplers and Tapestry Embroideries*, now happily reprinted by Dover Publications. The twenties saw the publication of Mrs Christie's *Samplers and Stitches* with an emphasis on the practical aspect of sampler-making. Leigh Ashton's *Samplers* of 1926 was written from an historical perspective and followed the first catalogue of samplers in the Victoria and Albert Museum by P. G. Trendell in 1922. The following three decades, dominated by the economic depression and the Second World War and its aftermath, furnished few relevant publications apart from F. G. Paynes' *Guide to the Collection of Samplers and Embroideries. National Museum of Wales* in 1939. As the world began to recover from the ruination of war, the beginning of economic revival and a new prosperity prompted a succession of exhibitions, catalogues, and books on the decorative arts. Most important for embroidery and samplers were two exhibitions, one in 1959 of British Embroidery at the Birmingham Museum and Art Gallery, and secondly the Victoria and Albert Museum's travelling exhibition of Elizabethan Embroidery in the years 1963–1964. 1964 also saw the publication of Averil Colby's book *Samplers*, and more than thirty years later it remains the standard work on English samplers. Written by someone who was both embroiderer and historian, it provides an historical analysis of the role and form of the English sampler over a period of more than four hundred years, and supplies a host of valuable insights into the spread of patterns and designs, changes in

embroidery fashion and female education, the effects of industrialisation, and much more. Since 1964 the floodgates have opened, and every year sees books, magazines, and exhibitions devoted to the sampler. Some simply repeat overworked cross stitch formulae, others look beyond the popular stereotype at the historical context of the sampler and its complex embroidery traditions. Increasingly research into the maker, her family, school, and neighbourhood is being done alongside the study of the actual sampler. This is particularly true in the USA where Betty Ring and many others have concentrated on this 'school girl art'. In the selection of samplers for this book, a necessarily limited attempt is being made to illustrate diversity of stitch, pattern, materials, and shape across both time and continents, and, at the same time, indicate the many similarities and continuities found on such work.

The sampler is one humble facet of the art or craft of embroidery. Whereas *opus Anglicanum*, luxurious embroidery made for the medieval church, has survived, contemporary domestic work, such as samplers of this early date, is unknown. Although there is a considerable body of references to embroidery in medieval literature, the earliest mention of samplers seems not to occur until the sixteenth century, when they feature quite frequently in wills and inventories. However, it seems reasonable to assume that nun and noblewoman would have stitched household and personal linen, and would have made use of an 'exemplum' for pattern and stitch reference. It may have resembled the fifteenth-century Mamluk sampler (no. 1) which is quite obviously an embroiderer's *aide-mémoire*. It was the combination of a more settled and increasingly prosperous society in the sixteenth century with the invention of the printing-press at the end of the fifteenth century, and the rapid expansion of its use, which meant that the increasing demand for secular decorative embroidery was both satisfied and stimulated by a flourishing trade in sheets and books of patterns.

The earliest known pattern books came off the presses of Germany in the 1520s. Amongst the few that survive, two of the best known are Schonsperger's of 1523–4 and Peter Quentel's of some three years later. Venice, a city long associated with the textile trade, was quick to develop as a centre of printing, and produced Vavassore's work in 1530 and Giovanni Ostaus' in 1561. These are simply a few of the best-known pattern books amongst a host of others, as well as a multiplicity of reprints, compilations and copies which were produced across Europe unhindered by any copyright laws. The books crossed not only national borders, but also the boundaries dividing various needle

techniques from each other. Frederic de Vinciolo, a Venetian working in Paris, published a book in 1587 describing his 'unusual and new designs' as being suitable for network, network with counted stitches, lacis, and cutwork. By 1591 it had been reprinted innumerable times and published in London. Another influential pattern book, Johann Sibmacher's *Schön Neues Modelbuch* was printed in Nuremberg in 1597 and was soon popular and plagiarised. Many of his patterns appeared in an English seventeenth-century bestseller, *The Needles Excellency* by John Boler. Equally popular was Richard Shorleyker's *A Scholehouse for the Needle* of 1624. Such was the appeal of the patterns and motifs in these books that they continued to be used and adapted for all needle techniques up to the present time. Unsurprisingly, they can be found on samplers across Europe from the late sixteenth century onwards, and later on those from North America.

The band and border patterns and detached motifs of many seventeenth-century samplers are obviously derived from printed sources. But, although strong similarities persist between the work of different decades and from different countries, it is rare to find an exact replication of a pattern. Two theories may explain these personal idiosyncracies. Firstly, many girls would not have been following the pattern at first-hand, but copying or adapting from the sampler or embroidery of a mother or governess. Secondly, a pattern that may originally have had a curvilinear element would have had to be 'squared-up' for counted-thread work, the predominant form of embroidery on seventeenth-century samplers. Hence the stylisation of flower, leaf, bird, animal, and figurative motifs. The most popular patterns and motifs were adapted for various needle techniques prevalent at the time; birds, flower sprigs, flower vases, etc. may be simply cross stitched on one sampler, worked in a variety of stitches or needle lace on others. Some of the floral and figurative 'spots' on seventeenth-century samplers (nos. 7 and 8) may well be based on woodcuts or early herbals rather than pattern books, and would have been drawn or traced onto the linen rather than following a pattern from a grid. None the less they were worked in a stylised manner. Sometimes a more individualistic approach was taken, such as in the depiction of small figures found only on English samplers and usually called 'Boxers'. These figures were either clothed or unclothed, facing or following each other, usually separated by a flowering branch, and carrying a 'trophy' in one hand. It is doubtful whether the young embroiderers gave much thought to the origin of the design. Various theories have been put forward and it seems

4

most likely that the 'Boxers' were based on illustrations of putti, a cupid or one of a pair of lovers. They became debased almost into a caricature by the limitations of the stitches used and even more by the custom of giving them contemporary embroidered clothes, their original symbolism quite forgotten.

Although there are differences in format and style between the English and the few Continental samplers illustrated, they are of identical materials and their patterns and motifs are based on similar sources. However, some motifs, both religious and secular, rarely occur on English samplers, but are part of the standard repertoire of Continental work. For example, the Crucifixion and the Instruments of the Passion (no. 18) are common to Catholic Europe, whereas orange or lemon trees in substantial pots (no. 19) seem to be particularly popular on German and Danish samplers of the seventeenth and eighteenth centuries. The horizontal bands of pattern found on many Continental samplers are not quite as dominant an arrangement as they are on English work, nor are the bands necessarily filled with repeat patterns. More often a selection of motifs and all-over patterns rather randomly fill the bands, but, as on English samplers, an alphabet is frequently included.

The advent of the alphabet and increasingly other forms of inscription on English samplers, from the mid-seventeenth century, hint at its changing role. The two earliest samplers illustrated (nos. 1 and 3) are obviously 'examples' of patterns and techniques, acting as a 'notebook' for the worker. They have no literary content. But towards the end of the century there was occasional reference in contemporary literature to schoolmistresses who combined the teaching of embroidery and elementary literacy, the sampler was becoming part of a structured school curriculum. At the same time decorative costume embroidery was being superseded by fashions that gave pre-eminence to rich silks cut to give a graceful flowing line with elaborate lace collars as the main accessory. Lavish costume embroidery was not to be popular again until well after the Restoration and towards the end of the century. It is strangely contradictory that, in the decades that saw the production of some of the finest samplers, the style and the techniques being taught so assiduously by parent and teacher were most unlikely to be transposed onto contemporary costume or furnishings. Many young girls of the era achieved technical competence by progressing from a coloured sampler to a more taxing whitework sampler, probably followed by a casket or cabinet furnished with various accessories such as pin-cushions, needle-cases, etc. Such an

embroidery education meant that young women were able to tackle the fashionable and frivolous complexities of English pictorial raised work seen not only on panels, but made up into caskets, mirror frames, cushions, etc. Popularly called 'stump work', it flourished in the latter half of the seventeenth century, and required a high level of technical ability.

Alongside this regime of increasingly complex stitching, a plainer style of sampler was emerging. Lettering displaced pattern, literacy rather than stitchery took precedence. Typical is the group of three samplers made in the 1690s (no. 12) which in turn are linked by style and inscription to another of 1691, held by the Museum of London, and the slightly later group of the early eighteenth century (no. 20). Research done by Edwina Ehrman of the Museum of London has established that the girls who made the samplers all came from landed families of the Ipswich, Suffolk area of England. Although considerable information has been obtained about such established families, it has not been possible to determine whether the inscribed Juda or Judeth Hayle, who was presumably from a humbler background, was a private governess or a teacher or 'mistris' of her own school. Nevertheless the samplers are typical of an evolving 'school style'. Another example (no. 21) of 1716, with more lettering than pattern bands, shows this increasingly popular arrangement. Throughout the eighteenth and nineteenth centuries most English samplers included a variety of alphabets, numerals, and improving or informative inscriptions. This format was equally popular in North America, but most Continental samplers eschewed the combination of literary and embroidery skills, and continued to concentrate on the latter. To some extent this must reflect the different priorities given to female education, women's position in society, and the class structure of that society.

The increase in lettering on the English sampler from the late seventeenth century onwards was not the only fundamental change that came about with the approach of the eighteenth century. The technique of stitching inscription required a limited range of stitches, and the sampler was increasingly a schoolroom exercise. It was no longer a repository of stitches and patterns kept at hand for easy reference. The neat alphabets and worthy texts became the chief concern, and the sampler could be displayed for general edification. It evolved into a more practical, even, rectangular shape which could be hung on a wall for all to see. Of course these changes in decoration and shape were gradual, and throughout the first decades of the eighteenth century many different styles continued to be made (cf. nos. 22, 23, 24 and

25). From mid-century onwards, the sampler bounded by a border on each side, usually with pictorial elements arranged symmetrically around an inscription, was well-established and was to be the dominant style of English and North American samplers for the next one hundred and fifty years.

The samplers that do not conform to the stereotype make interesting sub-groups, for example darning, whitework, map samplers, etc., especially as they were far from exclusive to Britain. Map and darning samplers, although very much eighteenth- and early nineteenth-century phenomena, were popular across national borders. Darning samplers seem to have been made quite early in the eighteenth century in Germany and Holland, and were then taken up in Britain and North America. Map samplers may well have derived from the whim of a schoolteacher who sought to interest her pupils in a map of a region, a country, or the world while they practised cross stitch. A publisher or pattern-maker soon saw the commercial possibilities of this idea, and printed map samplers were quickly mass-produced. Whitework, in constant demand through the centuries for personal and household linen, infants' clothing, and costume accessories, was perfected on samplers by competent young needlewomen. The extremely fine German or Danish example of 1853 serves to emphasise the point that such expertise was not limited to earlier centuries. The style of work may change, but the necessary skills did not (cf. nos. 14, 32, 60).

Despite the appeal of these less usual samplers, many girls continued to stitch in the traditional style of their country or region. Long band samplers retained their popularity in many areas of German-speaking Europe, although the strict arrangement of pattern bands gradually gave way to more random decoration such as the large uniformed figure of no. 41. Blocks or panels of all-over patterns, often called Florentine work, were another increasingly popular addition to the repertoire of patterns and motifs found on English and Continental samplers (cf. 24, 37). Florentine work was equally popular in North America and reflects the dedication of the eighteenth-century needlewomen to the production of embroidered upholstery and a host of smaller objects such as purses and needle-cases which were eminently suited to this style of stitching. More specifically, regional characteristics are well illustrated by Dutch samplers where motifs in the general European tradition accompany local favourites such as windmills, sailing-boats, and the lion rampant symbolising national independence (no. 39). Further north the samplers from the Friesland Islands and the northern

coasts of Holland and Germany (nos. 35 and 36) demonstrate the development of idiosyncratic decorative motifs and lettering where presumably local traditions were less influenced by metropolitan fashion.

Where sampler-making was exported from Europe to her then colonies, the conventions of the former were gradually re-interpreted and enhanced by local taste and traditions. The eighteenth-century Spanish and Spanish colonial samplers (nos. 43, 44, and 45) illustrate both the differences between styles in the first half of the century and the changing proportions of the sampler in the latter half. All three have in common a love of working with a multitude of bright colours, and a continuing interest in complex stitches and patterns. The latter was no doubt fostered by an education system dominated by the religious orders which had houses throughout Catholic Europe and her colonial territories. Fine needlework continued to be a vital part of convent education into the twentieth century. Such work contrasts greatly with that produced where mass education was being attempted, with the consequent simplification and standardisation of the needlework curriculum. Where embroidery continued to be the accomplishment of the privileged female (no. 44), particularly in a society sharply stratified into rich and poor and at some remove from industrialisation and an expanding middle class, standards remained high.

Settlement in the North American colonies was rather different; emigration not conquest was the driving force, and the immigrants were a mixture of nationalities and classes. From motifs, patterns, alphabets, and inscriptions with their roots in Europe, young settlers gradually developed recognisably different styles. The evolution of the American sampler in the eighteenth and nineteenth centuries has been, and is still being, assiduously researched. Historians and embroiderers increasingly produce evidence of particular teachers, schools, or religious groups such as the Quakers influencing young girls to the extent that their samplers are quite distinctive. Whilst few American samplers have found their way into European collections, the wealth of catalogues and books being published in the USA provides a means of comparing their work with contemporary European samplers. Somewhat different is the eighteenth-century Ottoman sampler (no. 46) which displays a mixture of Near Eastern and West European embroidery styles. This was not due to colonisation or conquest, but to the increasing influence of Western fashion, particularly French, in the lives of the elite rich of Turkey. Embroidered textiles have a long history of importance in the daily life of the

Ottoman world, and by the eighteenth century Western motifs and patterns were a frequent addition to the local repertoire.

Conquest, colonisation, and fashion spread diverse European embroidery styles across the world, but by the nineteenth century such variety was gradually diminished by the ascendancy of cross stitch. Frequently cross stitch was called sampler stitch, an indication of how closely object and stitch were identified with each other. At best the samplers displayed a pretty neatness, the result of exquisitely fine stitching (no. 51). More typical are those found in most local museums, usually gleaned from pupils of the surrounding schools. Worked in inexpensive materials, the usual composition of a rectangle worked with a border, a few symmetrically placed motifs, a verse, name, date, alphabet, and numerals, predominates. Borders, motifs, and inscriptions did still vary across Europe, but cross stitch was the dominant technique. Even when the long, narrow shape of past centuries was retained in parts of central Europe (no. 53) the complex stitchery of the past gave way to the ubiquitous cross stitch. If cross stitch had become international, another technique of the nineteenth century was also set to give a stylistic uniformity to samplers and then to embroidery in general. The coloured chart where each stitch was worked to correspond to one of the coloured blocks was widely adopted for the ease with which it was possible to copy patterns, motifs, and pictorial compositions. No thought had to be given to stitch or colour scheme. It was commonly called Berlin woolwork, having originated in that city. Some samplers are devoted to Berlin woolwork patterns (no. 54). Others have pictorial or patterned elements which suggest the use of a chart, not simply because of a rather pedestrian accuracy in the organisation of numerous colours, but also because similarly worked motifs often occur on other samplers and embroideries from a variety of places. A popular chart would provide the common source. By the nineteenth century, magazines and instruction books were easily and speedily distributed across country and continent, a stark contrast to the slow dissemination of design ideas in the early days of the printing-press.

If most girls in Europe and America by the mid-nineteenth century had come to regard sampler-making as a tedious cross stitch exercise, there was a minority who perhaps simply enjoyed the craft or had a specific need to learn a range of embroidery skills. It is they who kept alive the old purpose of the sampler, to learn and record stitches, patterns, and motifs. But the mechanisation and industrialisation that increased so rapidly from the eighteenth to

9

the nineteenth century dealt a harsh blow to traditional crafts; embroidery was no exception. Woven decorative textiles could be mass-produced, and machines were being invented to imitate hand embroidery and lace-making. From being a highly prized craft, embroidery was demoted to 'fancy-work'. It was regarded as a suitable occupation for the nineteenth-century female whose chores were done by servants and whose education and position in society decreed her only role in life was to be wife and mother. Beyond this narrow 'ideal' some women had to work, whether in the vast army of nineteenth-century servants or, for women clinging or aspiring to a higher social standing, as governesses and teachers. The samplers made by girls going into service or the schoolroom tend to be the more accomplished and interesting of the nineteenth-century output. Working samplers, such as no. 58, display not just accurate stitching, but a thorough grounding in lettering and useful, small, decorative border patterns, which would surely have helped a young woman to avoid the lowest levels of domestic service. Again it is the quality of the workmanship that distinguishes the mid-century whitework (no. 60) and the oddly shaped, plain-sewing sampler (no. 62). The former may well have been the work of a young woman who was going to specialise in the technique to earn her living; the latter was certainly the product of a trainee teacher. Both were concerned with the techniques that still had an importance at a time when much clothing was still made at home or by dressmakers, and when lace and whitework were still valued for infants' and women's clothing and fine household linen.

The increase of manufactured clothing and furnishing continued into the twentieth century which, combined with the upheaval of ordinary life across Europe brought about by the First World War, resulted in the near demise of the school sampler. Embroidery skills were obviously not a priority and were really only kept alive by the dedicated individual or in established workshops such as the Royal School of Needlework. The Art Schools saw a blossoming of interest in textiles in the 20s and 30s, and with it some returning interest in samplers and stitching techniques. The two twentieth-century samplers of these decades (nos. 63 and 64) reflect the artistic styles of their times but are interestingly different in purpose. One is more picture than sampler, and only closer study reveals the high quality of the embroidery and the many references to the motifs and pictorial subjects that would have been familiar to seventeenth- or eighteenth-century needlewomen. The other, although layered rather than long, reflects the true purpose of the sampler

with a wide range of traditional techniques and motifs, albeit worked in an unmistakably 30s style.

The revival of interest in embroidery that has occurred in the last two or three decades is not school based; the school sampler is most unlikely to enjoy a similar resurrection! At one end of the spectrum the craft has forged links with the fine arts, and at the other end it has become a favourite hobby. Where craft and art have amalgamated, traditional techniques are of little concern; the new liaison seeks to experiment and innovate. In the domestic world of the hobby, the sampler is generally worked as a conscious revival of the past, most usually the simple cross stitch format of the nineteenth century. But it is noticeable that gradually, and most perceptibly in North America, sampler kits and sampler instructions are encompassing a much wider range of stitches. With increasing confidence and expertise the embroiderer is regaining the skills of the past. Perhaps she or he will then increasingly use them to create twentieth-century samplers rather than re-create those of earlier centuries. Printed diagrams and instructions, even computer graphics, will continue to provide ideas and information at all levels of the craft. But it is only when thread is stitched into cloth that the aesthetic appeal of colour and stitch becomes apparent. If a leap is made beyond the embroidery kit of predetermined colours and stitches perhaps the sampler of today, as in the past, will continue to fulfil its role as a repository of ideas and techniques, even of experiment and innovation, combining the many new materials and design ideas of the late twentieth century.

PATTERN
DARNING SAMPLER

•

*Linen. Embroidered with polychrome silks in pattern
darning and running stitch. One selvedge edge, other edges
damaged and incomplete. The whole mounted on a linen backing.
37 (max.) × 30 cm. (max.). T. 166–1946.*

Several museums have Mamluk samplers amongst their collections of early textiles which derive from Egyptian archaeological sites. The interests of many archaeologists of the late nineteenth and twentieth centuries included excavated textiles. A. J. B. Wace, a distinguished classicist and appointed Professor of Classics and Archaeology in Alexandria in 1943, was perhaps the greatest collector. He gave much of his collection to the Victoria and Albert Museum where he was Keeper of Textiles from 1924 to 1934, and this early sampler to the Fitzwilliam in 1946.

The great variety of patterns found on this example are very close to those found decorating the many excavated fragments of clothing and household linen of a similar date. The repertoire of 'X', 'S' and interlacing patterns is also a familiar part of post-medieval European samplers and embroidery. Theories abound to explain such similarities. At one extreme is the idea of a Mediterranean 'folk memory' which perpetuated traditional patterns across land and sea, and which was eventually incorporated into early printed pattern books. A practical alternative suggestion is that the constraints of counted-thread stitchery and a plain woven material inevitably produces similar patterns in all cultures.

Whether samplers existed in medieval Europe is another mystery. None remain, and the earliest literary references date to the early sixteenth century. Rich, figurative ecclesiastical embroidery of the period survives, and it seems reasonable to assume that the wealthy also enjoyed and afforded decorative personal and household linen, possibly of domestic rather than professional production. Perhaps the fortunate preservation of the Mamluk samplers gives us a visual clue to what may have been similar decorative styles used domestically on samplers and thence on embroidery across Europe in the Middle Ages.

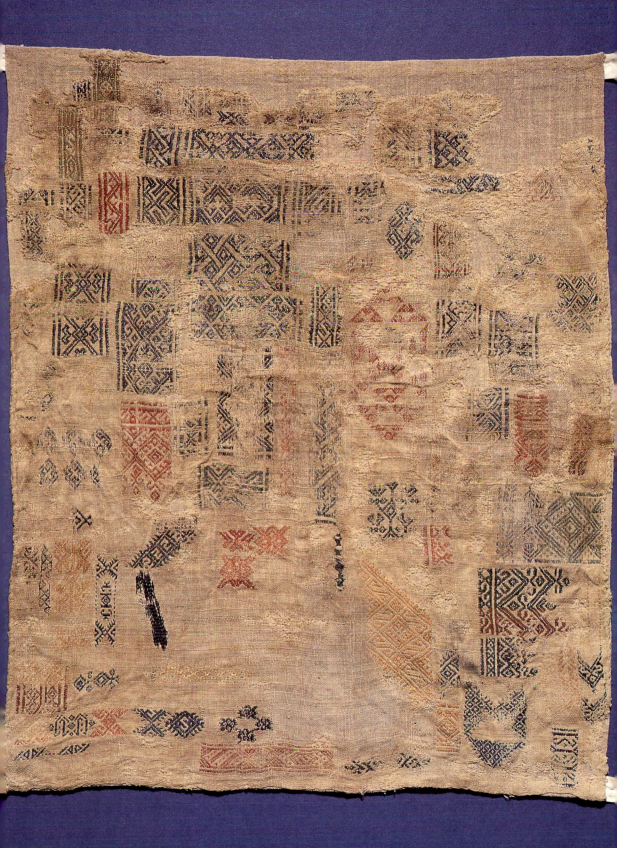

SAMPLER

ENGLISH, LATE SIXTEENTH OR EARLY
SEVENTEENTH CENTURY

—

*Linen. Embroidered with red,
green, and black silk, linen, silver, and silver-gilt
threads in back, buttonhole, hem, ladder, and plaited braid
stitches with various composite stitches. Cut and drawn work
with needle lace filling stitches. All edges hemmed.
20.5 × 16.5 cm. T. 2–1952.*

This modest undated sampler with seven square panels of embroidery, an unfinished band of needle lace motifs and small examples of metal thread work is similar in pattern, technique, and colour to three samplers securely dated to the late sixteenth or early seventeenth century. The Museum of London has a long band sampler of white cut and drawn work with two top panels which include embroidery in red and black silk and silver thread. The maker's name, Susan Nebabri, is inscribed, and, although not dated, she has worked the coat of arms of Elizabeth I and the initials 'ER'. The four needle lace motifs of the Fitzwilliam sampler are almost identical to some worked by Susan Nebabri. Jane Bostocke's sampler, dated 1598 and now in the Victoria and Albert Museum, is larger, 42.5 × 35.5 cm., but of similar proportions to the undated work. It is similarly worked with rectangular panels of patterns as well as various detached motifs. A third comparison can be made with a German sampler, also in the Victoria and Albert Museum, dated 1618 and inscribed Lucke Boten. Rather larger, 53.5 × 46 cm., its neatly arranged bands and rectangles of embroidery are predominantly cut and drawn work using linen thread or red or green silk. Several include needle lace filling stitches. All the samplers are linked by similar patterns, techniques, materials, and colour range. Stylistically the Fitzwilliam sampler would seem to reflect the complex embroidery techniques popularly used on English costume and accessories of the period, and also the common pattern sources available to both English and Continental needlewomen.

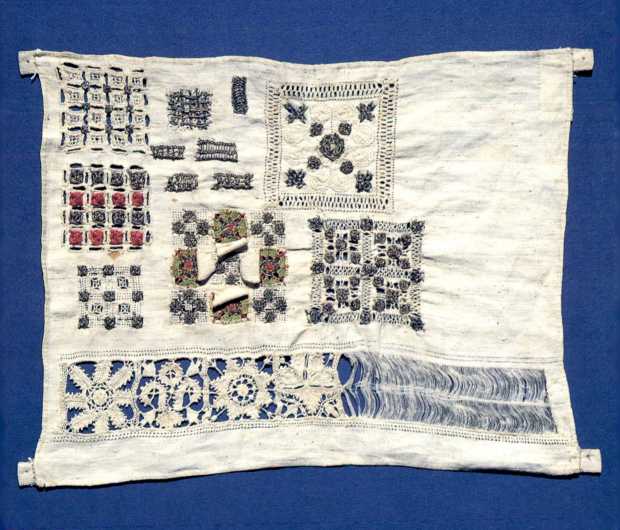

BAND SAMPLER

—

Linen. Embroidered with polychrome silks in
double running, cross, Montenegrin cross and satin stitch
with some speckling and detached needle lace stitches.
All edges hemmed. 16 × 64 cm. T. 1–1928.

Neatly worked bands of repeat patterns on a long narrow strip of linen are the most typical, and form the largest group of seventeenth-century samplers. Unlike the rare sixteenth-century examples of randomly placed and often unfinished motifs and patterns, which are probably the personal *aide-mémoires* of experienced needlewomen, this sampler, carefully planned and stitched by the inscribed '*elISABeth*', is most likely a schoolgirl's completed task supervised by a governess or 'dame'. The highly stylised floral repeat patterns and the limited, sombre range of colours is entirely consistent with work of this period. The inclusion of a date and name is unusual, although such inscriptions became increasingly common from the 1640s onwards. Of very similar date and format to the Fitzwilliam example is the work of Frances James, dated 1627. This band sampler measuring 17 × 54.5 cm. is part of Dr Goodhart's collection bequeathed to the National Trust and now at Montacute House in Somerset. In addition to formal bands of repeat patterns, both coloured and whitework, there is an alphabet worked immediately above the name and date. This is another feature that became increasingly common towards the middle of the century, as did versions of the small figures in the top band of Elizabeth's sampler. Colloquially called 'Boxers' because of their raised arm and clenched fist, usually grasping an object interpreted as a branch, bouquet, or flower, they are popularly identified as cupids or Renaissance putti. They are most probably derived from the pairs of lovers illustrated in early Italian pattern books. The shape, the materials used, and the arrangement and content of the embroidered decoration of the rare early seventeenth-century samplers all indicate what was to become the popular and prolific style of work of the later decades.

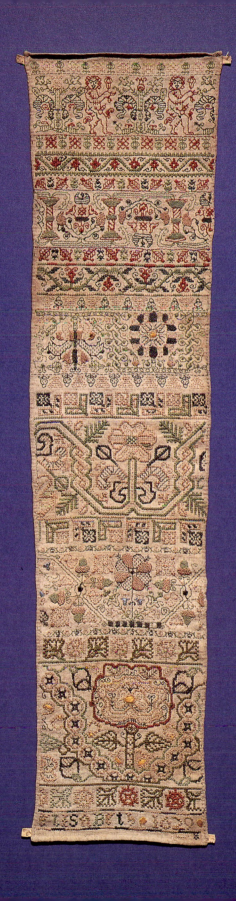

DETAIL OF A
BAND SAMPLER

ENGLISH, 1656

*Linen. Embroidered with polychrome
silks in double running, satin, cross, Montenegrin cross,
long-armed cross, and trellis stitch with some detached
filling stitches. All edges hemmed. 19 × 74.5 cm.
T. 21–1928.*

Although this sampler is of a similar long and narrow shape to that dated 1629, and is also composed of horizontal bands of repeat patterns, there is a quite obvious difference in colour and style.

The more restrained stitching of the unillustrated upper bands closely resembles the light, linear patterns of the 1629 sampler. But in this detail it can be seen that the sombre shades of the early seventeenth century have been supplemented by brighter silks in a wider colour range with a much greater use of lustrous, lightly twisted silks. These silks, worked in bolder blocks of colour, give a very different impression to the earlier, more sparsely stitched bands. Although the style of embroidery gradually changes, the favoured patterns of flowers, fruits, and leaves continue to dominate and to be used in a stylised rather than naturalistic fashion. They are still organised within the geometric meanders or arcades that control the scale of the repeat pattern.

The greater range of silks is an indication of an increasing growth in trade during the seventeenth century. The establishment of the East India Company in 1600, soon followed by other merchant companies, to promote trade with India and the Far East, gave the English embroideress easier access to a wealth of silk threads. Although her work became more brightly coloured, the continuing use of traditional patterns over many decades suggests that she looked back to the work or ideas of previous generations, and that neither she nor her mentor were much interested in innovation. The equally traditional alphabets, one complete, one incomplete, are also to be found in the final bands with the inscription 'Ellenor Wykes 1656'.

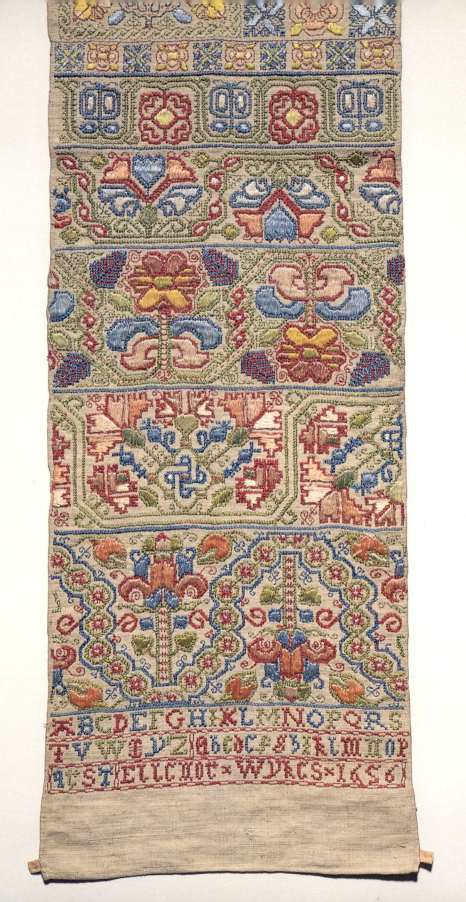

5

BAND SAMPLER

ENGLISH, MID TO LATE SEVENTEENTH CENTURY

Linen. Embroidered with polychrome
wools in double running, cross, long-armed cross,
Montenegrin cross, Algerian eye, and buttonhole stitch
with some speckling and detached filling stitches.
All edges hemmed. 21 × 74 cm.
T. 66–1928.

Although undated, the sampler is inscribed at the top with the name 'MArie Ab/bott', an alphabet, and the words 'Have god in minde'. Similar moral or religious phrases are found not only on English samplers of this period, but also on domestic pottery, and reflect the common preoccupation with both contemporary religious upheavals and the unpredictability of life and death.

This has a more spontaneous feel than many band samplers of the period: as well as densely worked horizontal bands, there is a small area devoted to all-over patterns. Most of the bands do not span the whole width, the left-hand side being used for additional horizontal and vertical repeat patterns, the latter of a particularly large scale. Amongst the patterns are those particular English favourites based on the oakleaf and acorn, the stylised rose, and the ubiquitous 'Boxers'. Many of the patterns were undoubtedly based on those in early German and Italian printed books, the interpretation of such patterns depending very much on the style of the original. Stylised, geometric motifs translate easily from printed page to counted-thread stitching. The many free-flowing, curvilinear patterns found in Renaissance pattern books would have had to be quite radically adapted, for example the meandering stem or branch would have been worked as a rigid arcaded band, flower petals would have assumed a geometric form, and figures become stylised, sometimes close to caricature.

Although the embroidery typifies that of seventeenth-century samplers, the use of wool rather than silk is much less usual. Wool being cheaper but less robust than silk, it seems likely that a child's first attempts at stitching were in wool, but this sampler shows that very high quality work was executed in the cheaper material. Possibly much wool work has been lost to the appetite of the moth, whilst the less vulnerable silk-stitched samplers have survived.

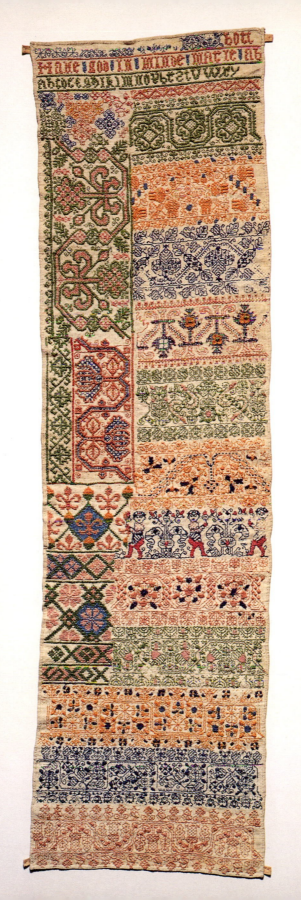

DOUBLE BAND SAMPLER

ENGLISH, MID TO
LATE SEVENTEENTH CENTURY

—

*Linen. Embroidered with polychrome
silks in cross, Montenegrin cross, double running,
satin, and trellis stitch with some speckling. Silver metal
thread couched and interlaced. Sides hemmed, selvedge
at top and bottom. 40 × 62.5 cm. T. 19–1938.*

A vertical band in the centre of the sampler contains two incomplete alphabets divided by small motifs with 'ER' worked at the top. To either side are meticulously worked horizontal bands. The stitching is particularly accurate, and an overall impression of evenness and balance is given by the painstaking arrangement of the repeat patterns. This lack of spontaneity very much suggests it is the product of a carefully supervised school room exercise towards the end of the seventeenth century. This date is further corroborated by its similarity to a sampler in Dr Goodhart's bequest to the National Trust, kept at Montacute House, Somerset. That sampler is slightly smaller (38 × 63.5 cm.) but has a similar format of two sets of horizontal bands with a central vertical band inscribed with two alphabets, 'EW' and also the date '1682.' Several of the repeat patterns on the two samplers are identical. Almost certainly they are all based on popular pattern books published in England throughout the seventeenth century, for example Shorleyker's *A Schole-house for the Needle*, probably first published in London in 1624, or Boler's *The Needle's Excellency* of some seven years later. The English publications were compilations of copied or adapted patterns from earlier Continental books, early cases of printed plagiarism! The bird and flower pattern is found on English and Continental samplers in both coloured and whitework, and can be traced back to the widely used and reproduced *Les Singuliers et Nouveaux Pourtraits pour touttes sortes d'ouvrages de Lingerie*, published in France in 1587 by the Venetian, Frederic de Vinciolo.

Coincidence is an unlikely explanation for such similarities of size and pattern on the two samplers. Presumably 'ER' and 'EW' were instructed by the same teacher. Another snippet of information can be gleaned from the National Trust sampler. Inscribed in black silk over ink along the lower edge is '*When this was made shee was 11 years olde*'.

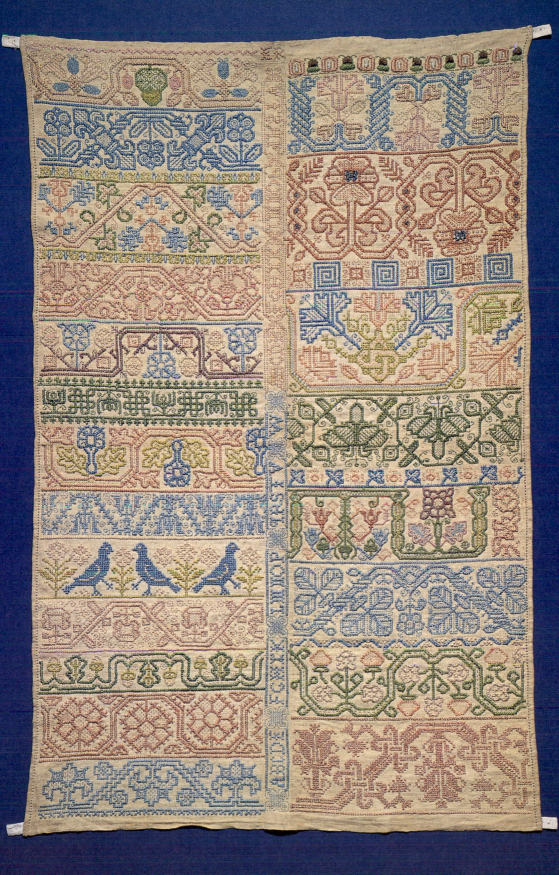

SPOT MOTIF SAMPLER

—

Linen. Embroidered with polychrome silks in tent,
cross, long-armed cross, back, chain, eyelet, rococo, and faggot
stitch with pulled work. Silver and silver-gilt thread work in braid
and interlacing stitches, laid and couched work with one spangle.
Three edges hemmed, selvedge with single blue line on
right side. 27 × 42.25 cm. T. 2–1928.

Not frequently found in public or private collections, spot motif samplers are also infrequently dated. It is often written in books about samplers that the scarcity of this type implies an early seventeenth century date. Since the publication of Dr Goodhart's collection, now with the National Trust, this assumption has been proved incorrect. Dr Goodhart's collection is particularly rich in spot motif samplers. Most are undated; four are dated to 1640, 1657, 1670, and 1674 respectively.

The decoration of this sampler comprises some forty detached motifs with additional small panels of metal thread stitching techniques and the initials 'MC' worked in faded pink silk in the top left corner. The 'spots' are geometric or stylised floral or a combination of both, often worked as an all-over or diaper pattern. In the centre there is the coat of arms of the Chichesters of Arlington, Devon. From this it is possible to give a tentative date to the sampler. Henry Chichester fathered two daughters with the right initials, Mary in 1615 and Margaret in 1619. Either could have been the maker which would indicate a date somewhere between the late 1620s and late 1630s. The motifs, presumed to have been worked before 1640, are similar to those on samplers of a later date, thus adding weight to the theory that patterns were repeatedly worked by succeeding generations of girls. Originally they probably reflected contemporary fashionable embroidery, but by the 1630s the use of complex embroidery on costume had declined, and the execution of such work on this sampler was probably more to do with learning traditional techniques than producing patterns and designs suitable for mid seventeenth-century use.

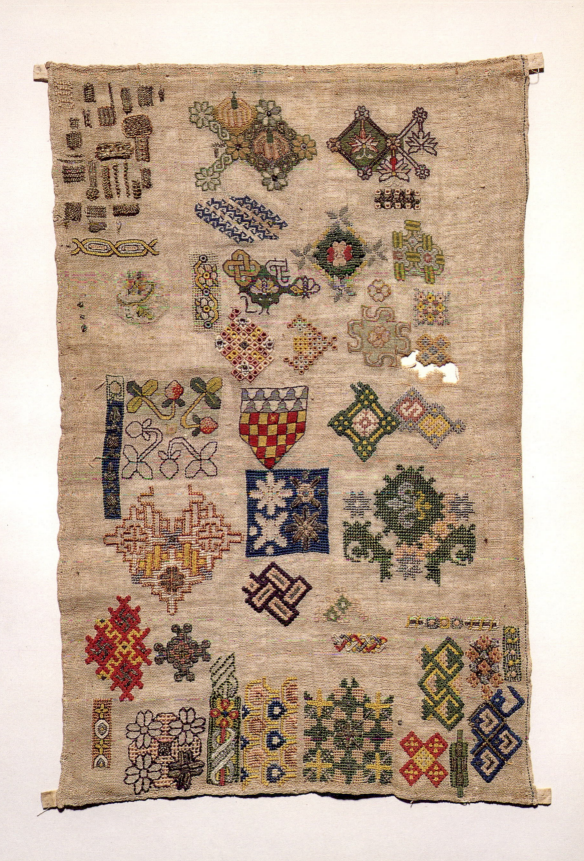

SPOT MOTIF SAMPLER

—

Linen. Embroidered with polychrome silks
and silver metal thread in tent, back, chain, and interlacing
stitches with laid and couched work. Three edges hemmed,
selvedge with partial single blue line on bottom edge.
21.25 × 37.25 cm. T. 3–1928.

In some respects this sampler is similar to the previous one of the Chichester family. It too carries a coat of arms, thought to be that of the Birt or Burt family of Devon, and the initials MB in faded pink silk. The motifs or 'spots' are also randomly placed, but include several naturalistic designs quite unlike the counted-thread work of diaper and all-over patterns worked alongside and which predominate on the Chichester sampler. The flower, fruit, animal, bird, and insect designs have been drawn onto the linen in outline; several are unfinished and the line drawing is clear. The embroidery itself is shaded and speckled to give a realistic effect, greater success being achieved in the representation of some of the smaller floral motifs than in the larger one or in the depiction of animals. But even the more stylised work, such as the English rose, is far from the strict counted-thread geometric roses found in band samplers of a similar date.

As with practically all the motifs and patterns of all types of seventeenth-century samplers, it is almost unheard of to find an absolutely exact reproduction of a pattern from a printed book, although most would seem to derive from a printed source. The clear but not especially confident drawing exposed on this sampler suggests a girl or governess copying and, deliberately or not, adapting a motif, possibly from a printed sheet or book, or alternatively from another embroidery. The inclusion of an obelisk in the lower left-hand corner is a less usual motif than the familiar floral and figurative work. Although obelisks or pyramids can be found occasionally in printed works, they only started to become generally popular during the reign of James I, and even then rarely on a sampler. In the lower right-hand corner there is an inked inscription which under magnification could be 1655, an entirely reasonable date for this sampler.

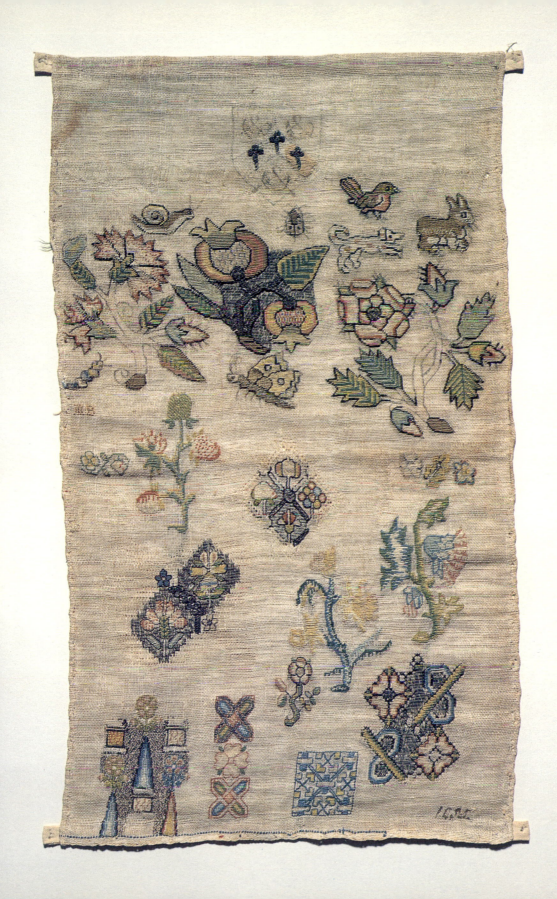

PICTORIAL BAND SAMPLER DETAIL

ENGLISH, POSSIBLY DATED 1655 OR 1665

•

Linen. Embroidered with polychrome silks in cross,
Montenegrin cross, double running, satin, split, trellis, and
detached buttonhole stitch. Linen thread worked in hem, double
running, counted satin and eye stitch with needle weaving,
drawn and cut work with needle lace filling stitches.
Three edges hemmed, selvedge at top.
24.5 × 74.5 cm. T. 15–1928.

The lower three conventional floral arcaded bands of this sampler are not illustrated. Immediately above them is the large-scale arcaded pattern with birds, probably woodpeckers. Despite the more naturalistic and spontaneous working of the birds, they are not the unique idea of an individual girl. An almost identical 'woodpecker band' can be found in the Embroiderers Guild collection. This is not the only similarity. The band above and below on both are almost identical, as is the 'bird and flower' whitework band, although the Guild's example is not upside down! The 'bird and flower' pattern is a familiar one on seventeenth-century samplers (cf. no. 6), both English and Continental, but the use and combination of less usual ones, particularly the distinctive woodpecker motifs on two mid seventeenth-century samplers, does suggest something other than a common printed source. Possibly they were worked for the same governess or teacher, or were particular to a school.

The widest band is pictorial with two figures, dressed in the fashion of the 1650s, standing either side of an apple-tree. Pictorial embroidery flourished in the latter half of the seventeenth century. Religious, mythical, and secular subjects were all popular and usually worked within one of the conventional arrangements of figures. On this sampler the figures of a fashionably clothed man and woman would seem to be secular adaptations of the less well-clothed Adam and Eve standing either side of a tree with entwined serpent. The inscription above includes an alphabet, the name 'ANNe LaWLe', with remnants of stitching and faded ink reading '*February*'. The less decipherable date could be '1655' or '1665'. The inclusion of figures and the use of raised and detached stitching techniques makes this sampler an especially accurate reflection of contemporary embroidery style.

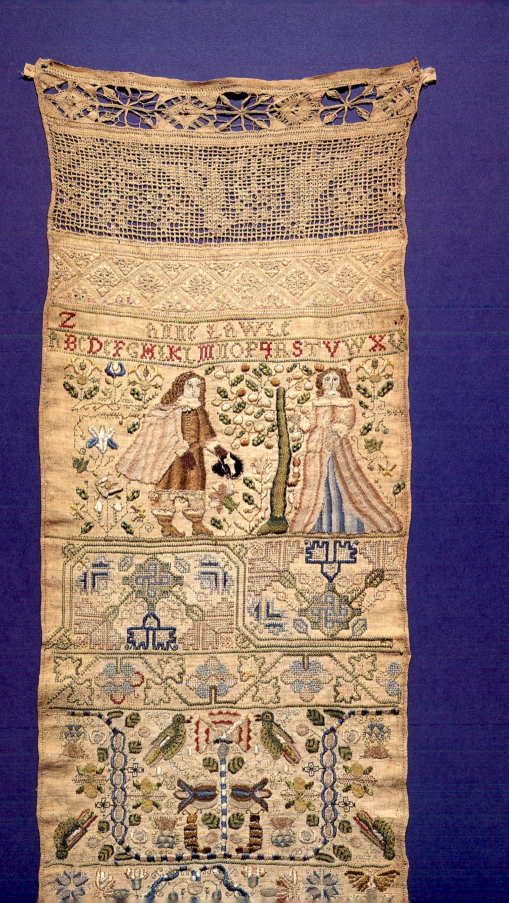

PICTORIAL BAND
SAMPLER REVERSE

ENGLISH, 1660S

—

*Linen. Embroidered with polychrome
silks in double running, running and cross stitch.
All edges hemmed. 18.25 × 59.5 cm.
T. 31–1928.*

The dominance of double running stitch on this sampler contrasts with the complexities of stitch and technique common on much work of this date. Because of fading, the lightly delineated patterns are difficult to decipher, but, by studying the reverse, clarity and some strength of colour are restored. Familiar forms predominate; among them are 'Boxer' figures, the bird and acorn, the interlacing 'S', and arcaded floral bands. Two pictorial bands are quite different. The lower band includes part of a palatial building, a male figure, animals, flowers, and an oak tree supporting three crowns. Theories abound as to the symbolism of embroidered motifs, when often it would seem more sensible to assume that a young girl chose patterns and designs she liked with little thought of their possible significance. However, an oak tree and golden crowns are much more specific. They are a deliberate reference to the Boscobel Oak, then growing in the grounds of Boscobel House, Shropshire, which sheltered Charles II as he fled from disastrous defeat at the Battle of Worcester in 1651. The figure of a huntsman and the animals perhaps illustrate his support by the local country people.

The crenellated building and parterre or knot garden of the higher band are worked in association with the Boscobel Oak band on at least two other samplers. Frances Cheney's sampler, dated 1663, is in the Burrell Collection, Glasgow; another, dated 1660 and worked by Elizabeth Sexton, recently passed through a London auction house. The Fitzwilliam's example lacks date and name, but can be presumed to date from the 1660s by which time support for the Royalist cause was no longer dangerous. Samplers were perhaps the first steps in inculcating political or historical awareness in a young woman. Others record diverse events such as the landing of the Prince of Orange (later William III) and the earthquake in London in 1692.

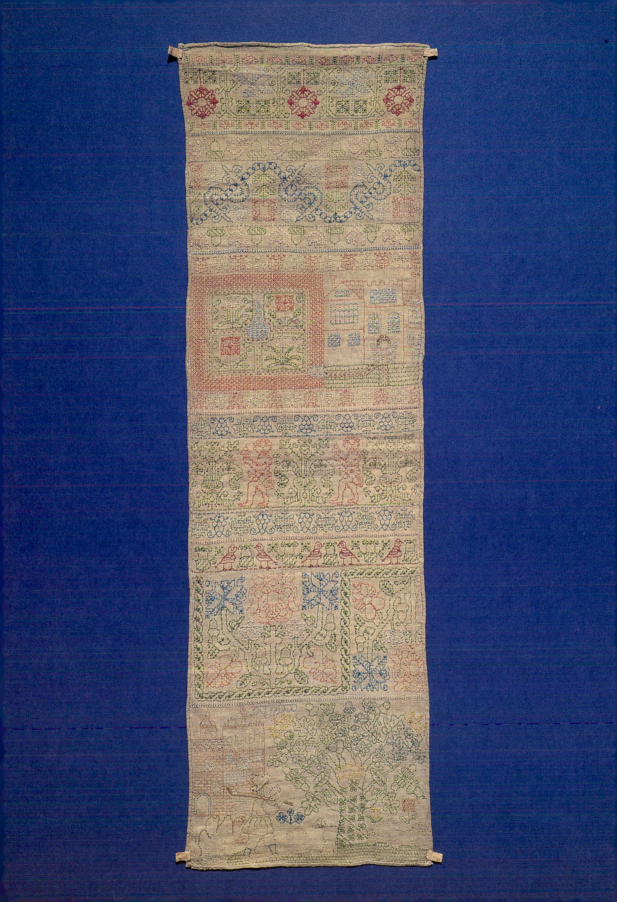

SPOT MOTIF
AND BAND SAMPLER

ENGLISH, 1675

⬥

*Linen. Embroidered with polychrome silks in double
running, running, back, satin, eyelet, cross, Montenegrin cross,
trellis and detached needle lace stitches. Three edges finished with buttonhole
stitch, selvedge at top. Two joined pieces, upper 12.75 × 26 cm.,
lower 12 × 15.5 cm. T. 57–1928.*

This sampler is unusual in that it includes horizontal bands of inscription
with dozens of small spot motifs above and below. The inscription is made up
of two alphabets, the name 'Ioyce Leedes' and the date '8 JVNE 1675'. At the top
there is an incomplete alphabet and numerals in rather less structured bands.
There is also a small panel with the initials 'IL' at the bottom of the sampler.

Many of the small floral sprigs, animal, bird, and insect motifs are typical
of those found on both seventeenth-century samplers and embroideries. The
range of human figures is less usual, especially those mounted on horse or
donkey. There are two versions of a male and female figure flanking a flower-
ing branch, one of which includes female costume in raised worked stitches,
adding a touch of realism to the composition. The male costume has almost
completely disappeared, but the stitch holes indicate that it was also raised
work. Both sets of figures resemble small scale versions of those discussed
on the sampler of 1655 or 1665 (no. 9), i.e. based on Adam and Eve. The lion
and the mermaid may well be simple interpretations of figurative designs that
were also used as heraldic devices. They are not found as stylised patterns
incorporated into repeat band patterns but generally occur on spot motif
samplers which often carry coats of arms. There is a sampler of 1630 in the
Dorset County Museum which has many of the characteristics of this sampler
despite being some forty-five years earlier. It has a modest band of inscrip-
tion, but otherwise it is covered in numerous small figurative motifs, includ-
ing a man and woman holding hands; it also has panels of geometric patterns
and a central panel with a crown and heraldic animals. Only young women
from the privileged upper echelons of society had the leisure and wealth to
devote to fine embroidery. They would therefore almost certainly be aware of
coats of arms and heraldic devices, and reflect this in their work.

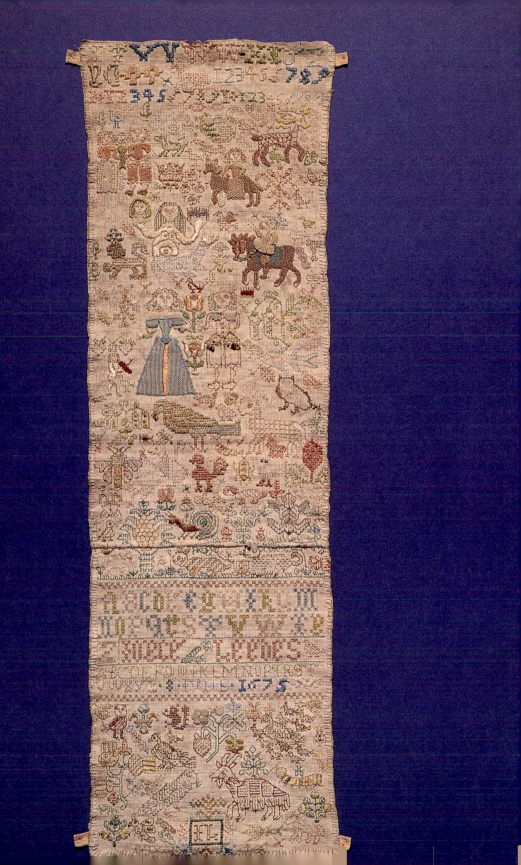

THREE RELATED BAND SAMPLERS

ENGLISH, 1691, 1693, AND 1694

Linen. Embroidered with polychrome silks in cross, hem, double running, Algerian eye, satin, chain, whipped stem, and trellis stitch. Each sampler has its side edges hemmed and a selvedge at top and bottom. 16.5 × 52 cm.; 17 × 53 cm.; 16.25 × 55.5 cm. T. 83–1928; T. 1–1995; T. 17–1938.

Of similar size and format, these samplers are part of a group linked by the name of a 'dame' or 'mistris' and identified by the inscription of 'IUDA' or 'IUDETH HAYLE' or the initials 'IH'. A fourth almost identical sampler, dated 1691, is in the Museum of London. Another four samplers, dating from the beginning of the eighteenth century and stylistically rather different, are also related to these earlier works and carry either the initials 'IH' or identical verses and motifs.

It has already been suggested that samplers with distinctive designs such as the Boscobel Oak or 'woodpecker' bands are survivors from larger groups, which were connected by girls having the same teacher, pattern drawer, or political loyalties. The Iuda Hayle samplers are quite explicit; she was a 'dame' teaching over a period of ten years or more.

Typical of work of the late seventeenth century is the dominance of lettering over pattern bands. Literacy had become increasingly important for young females, and the stitching of name, date, alphabets, and improving verses was seen as a means of instilling basic secular and moral education. The worthy sentiments expressed on the 1694 sampler: 'LOOK WELL TO WH | AT YOV TAKe IN HA | ND FOR LARNING IS | BETTeR THeN HOV | Se OR LAND WHeN L | AND IS GONE AND MO | NeY IS SPeNT THeN | LARING IS MOST eX | CeLeNT. AVGVST The 18 1694' are found on many samplers of similar date, the Royal Scottish Museum having the earliest known one of 1680.

The growing importance attached to lettering and literacy inevitably reduced the stitch variety on samplers. At the same time the fashion for complex embroidery was declining, but a young woman still needed to work a sampler to learn basic needle skills, even if she was required to do no more than work simple decoration, or to mark the large amounts of personal and household linen required by an increasingly prosperous population.

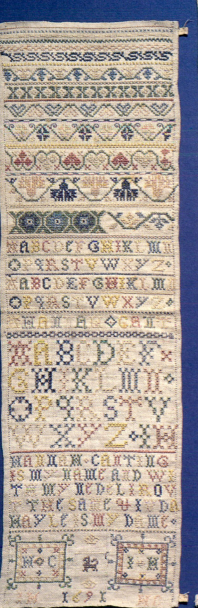
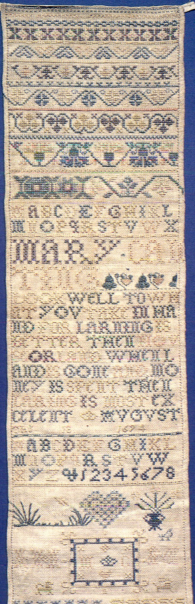
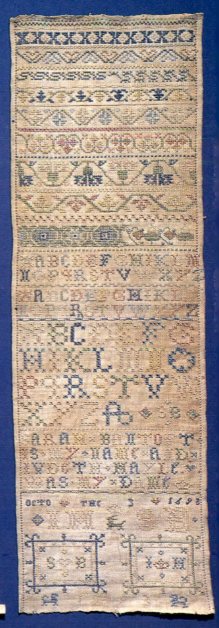

TWO WHITEWORK SAMPLERS

ENGLISH, 1643

*Linen of two types. Joined strips enclosing a cutwork panel worked
with linen thread in needle lace filling stitches. A second panel is also worked
with linen thread in hollie point with picot bars. The bottom strip is embroidered
with linen thread in satin and double hem stitch. Edges finished with
buttonhole bullions. 16.25 × 15 cm. T. 4–1928.*

ENGLISH, 1648

*Linen. Worked with linen thread in double hem stitch, cut and drawn
work with needle lace filling stitches, pulled work, hollie point, and superimposed
buttonhole stitch. All edges hemmed. 19.5 × 19.75 cm. T. 7–1928.*

Whitework band samplers, occasionally combined with coloured work, are not uncommon in the seventeenth and early eighteenth centuries, though complex small samplers are less usual. Showing a high degree of skill, they would have been undertaken only by a girl who had already demonstrated an aptitude for fine stitching. Whereas coloured samplers of the 1640s bore little relationship to contemporary fashion, and functioned more as repetitive schoolroom exercises, whitework continued to have a practical connection with small items of costume and accessories produced in the domestic environment. Fine lace was imported in increasing quantity but at prohibitive cost, hence the demand for cheaper alternatives. A capable young woman could have been expected to make sleeve frills, collars, bands, trimmings for caps, coifs, christening robes, etc.

These patterns are based on, rather than copied exactly from, favourite publications such as Sibmacher, Vinciolo, or Shorleyker. The lettering on the 1648 sampler is similar to one at the Victoria and Albert Museum (269–1898), both resembling an alphabet in Giovanni Ostaus' pattern book of 1557. ELIZABETH HINDE's figurative panel is one of the few whitework pictures surviving as either part of a sampler or independently. It probably depicts the story of Abraham and Sarah, illustrated bibles being another popular source of inspiration for pattern drawers and embroiderers.

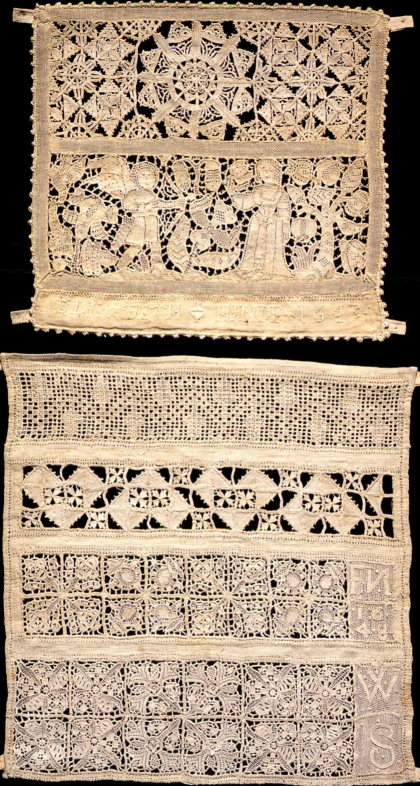

WHITEWORK BAND SAMPLER

—

*Linen. Embroidered linen thread in hem and
whipped stem stitch with French knots, buttonhole bars
and pulled thread work. Three edges hemmed, needle
lace edging along bottom edge, selvedge at top.
13.75 × 45.5 cm. T. 130–1938.*

Several of the bands of this exquisitely worked sampler appear to be based on patterns from Sibmacher's *Modelbuch*, first published in Nuremberg in 1597 and soon copied, adapted, and dispersed across Europe. An English version called *The Needle's Excellency* had run to ten editions by 1624. It proved so popular that it was reprinted in Germany until the late nineteenth century. One particular pattern, the almost architectural shape on the upper sampler which is actually a design for the opening of a shirt front, is very similar to that illustrated in a 1601 edition of Sibmacher.

This sampler was originally in Mrs Longman's collection, and she very frequently made notes about the place, date, and price of her purchase, or by whom it was given, and other snippets of helpful information. Unfortunately this is not the case with this one. The fineness of the linen and the delicacy of the work are not quite like the more robust English whitework samplers, nor do the bands of repeat patterns appear to have any particularly English characteristics. Embroidery of this quality can be found on German, Italian, and Swiss samplers of the seventeenth century; the long, narrow format was also widely used. Whether English or Continental, it is not the work of an ordinary child. Not only are the patterns, especially the shirt front opening, organised with exceptional accuracy and balance, but the stitching is just as exceptionally precise. It could have been worked by a very competent young woman, but the quality of craftsmanship and its finished appearance suggest it might have been made by a teacher as a demonstration of technique for her pupils. This level of skill and lack of spontaneity are more typical of late seventeenth-century work, but realistically provenance and date remain debatable.

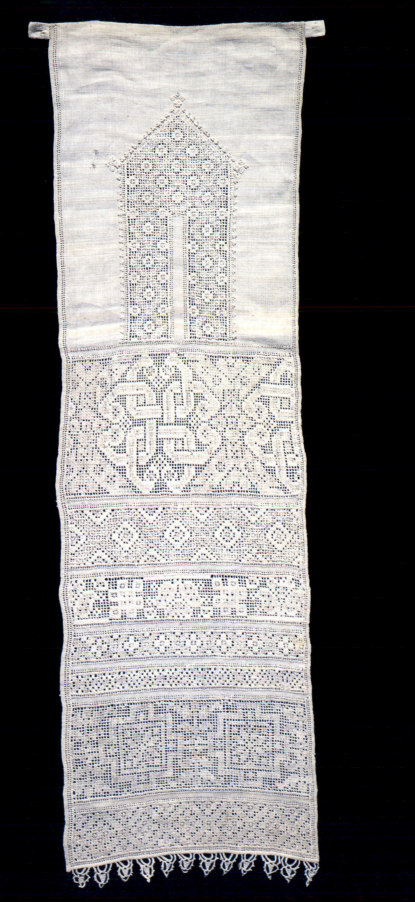

MIXED BAND SAMPLER

ENGLISH, MID TO LATE
SEVENTEENTH CENTURY

●

*Linen. Embroidered with polychrome silks in running,
double running, cross, Montenegrin cross, and with some speckling
stitch. Linen thread worked in double hem, counted satin, and square filling
stitch with buttonhole bars, pulled work, cut and drawn work with hollie point
and needle lace filling stitches. Silver metal thread worked in interlacing and
braiding stitches, cross stitch, laid and couched work, and needle
woven bosses. The edges hemmed, selvedge at bottom.
18 × 87 cm. T. 7–1938.*

This use of three embroidery techniques, coloured, white, and metal-thread
work, arranged in three distinct sections on a band sampler, is very much
rarer than the simpler combination of bands of coloured and whitework
which occurs on some of the more sophisticated examples from the mid cen-
tury onwards. The most distinctive features are the panels of metal thread
work and all-over patterns. These very narrow panels exhibit techniques that
are seen randomly placed on some spot motif samplers. The bosses and intri-
cate laid and couched work may well be unique; even the more familiar all-
over patterns are not usually placed in a frame. The inscription 'IC' is worked
in cross stitch in silver-metal thread, a material more usually laid and
couched rather than penetrating the linen.

The coloured embroidery includes an alphabet band and initials IC, but
there is no further inscription. The use of a sunflower in the arcaded pattern is
possibly connected with van Dyck's use of it as a symbol of his loyalty to
Charles I and its consequent use by those sympathetic to the Royalist cause.
The light palette and one very wide band suggest a date towards the end of the
century, although some samplers of that date continued to be embroidered in
traditional strong colours. There are two fine examples of this type in Dr
Goodhart's bequest to the National Trust, dated 1692 and 1695 and worked by
two sisters, Alice and Margaret Jennings. The whitework, conventional in
style and repertoire, shows a high degree of skill. Obviously samplers such as
this are not a child's first attempt at embroidery, but the work of a competent
older girl.

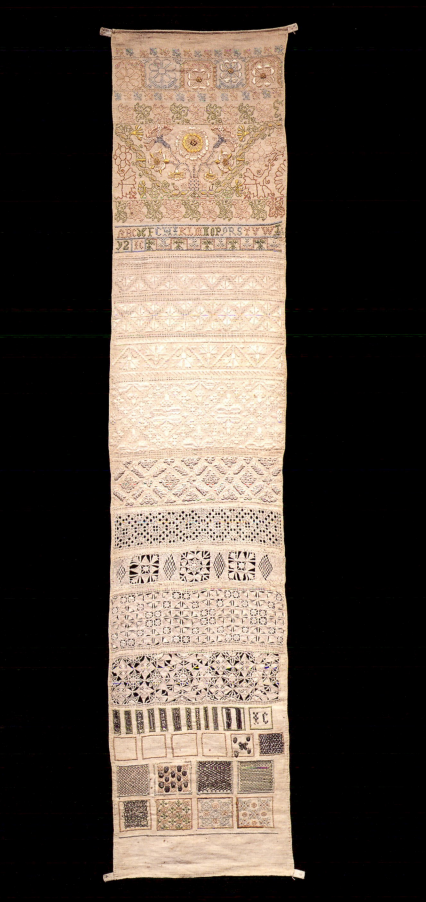

MIXED BAND SAMPLER

ENGLISH, 1699

AND 1700

*Linen. Four joined pieces embroidered with polychrome
silks in satin, eyelet, cross and double running stitch. Linen thread
worked in buttonhole and hem stitch, cut and drawn work with needle
lace filling stitches and hollie point. All edges hemmed.
19.25 × 32.25 cm. T. 20–1938.*

The upper section is made up of a conventional arrangement of bands of simple repeat patterns, alphabets, numerals, and the inscription 'SVSANNA WILKINSON 1699'. All are worked in the light and limited palette of colours associated with late seventeenth-century samplers. A complete band of cutwork is worked just above the joins to the lower section, which comprises two narrow vertical strips of linen to either side and one along the bottom, forming a frame for the panel of needle lace and hollie point.

The figurative panel of a male and female is not totally dependent on a cutwork grid; part is worked as freely made needle lace (*punto in aria*) and then inserted into the sampler. The design for the male and female is based on one published in Sibmacher's *Modelbuch* of 1601, with the two figures here divided by a vertical band of hollie point inscribed '17 SW 00'. Versions of male and female figures were in popular use across Europe throughout the seventeenth and eighteenth centuries, and worked as cut and drawn work, in various whitework and coloured forms of embroidery, as well as needle lace. Patterns were easily available to English needlewomen with their inclusion in John Boler's *The Needles Excellency*, which had appeared in twelve editions by 1640.

Numerals and coronets fill the final two bands of the sampler with a small repeat pattern worked vertically either side of the pictorial panel. This concept of a picture within a frame was to become increasingly common and then the norm of the following two centuries, but, worked between 1699 and 1700, it is an early and rare hint of the evolution of the sampler from a stitching exercise to an embroidered picture within an embroidered border. At that point it became suitable for framing and hanging on the schoolroom wall. It was no longer a work of reference to be kept at hand, in work box or bag.

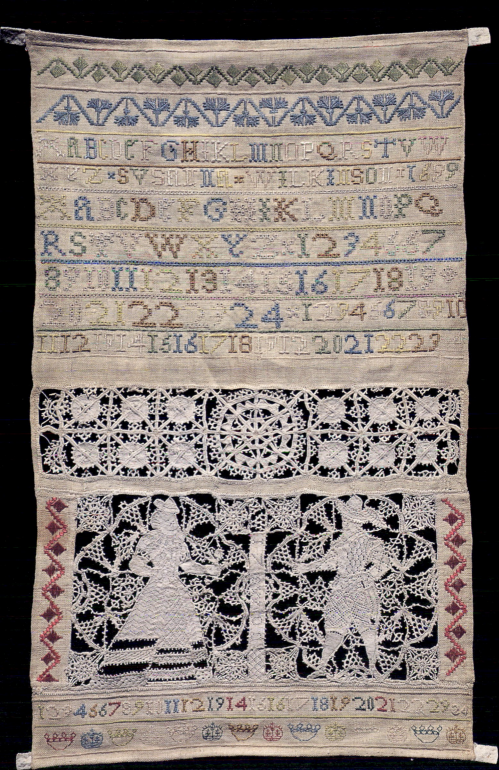

SAMPLER

POSSIBLY SWISS OR
AUSTRIAN, 1675

⬥

Linen. Embroidered with polychrome silks in
double running, cross, long-armed cross, stem, and satin stitch.
All edges hemmed. 42.5 × 43.75 cm. T. 126–1938.

This almost square sampler is covered in a wide range of patterns, figurative, geometric, and floral, loosely arranged around a central motif of a pierced heart within a wreath. There are three corner motifs, including one with stylised clasped hands. The fourth corner has only small 'spot' motifs. Repeat pattern bands of various scales dominate two sides with 'spot' motifs on a third. The fourth side carries an alphabet, the initials 'EH', and the date of '1675' above which is a row of sprigs and vases of flowers, a horse, lion, deer, and bird, and one male and one female figure. Their simplified costume looks typically seventeenth century, but there is not sufficient detail to conjecture about nationality. The central wreath is surrounded by spot motifs, linear in character, mainly worked in double running stitch. All the patterns and motifs are probably derived from the popular pattern books of the seventeenth century which circulated throughout Europe. The use of a single line of stitching for the spot motifs is a style usually associated with work from German-speaking Europe, whilst the use of the pierced heart symbolising the Christian Sacred Heart usually denotes a Catholic background. A sampler in the Palazzo Davanzati, Florence, although long and narrow, includes similar corner and floral motifs, an alphabet, and a centrally placed Sacred Heart within a wreath. It is believed to date from the last quarter of the seventeenth century and to come from the region of Styria, Austria. Similar in size with a multitude of spot motifs, all-over and corner patterns is the Victoria and Albert's German sampler, dated 1661 and inscribed with a comparable single alphabet. The illustrated sampler was purchased in Zürich in 1886, and was almost certainly made within German-speaking, Catholic Central Europe, probably in Switzerland or neighbouring Germany or Austria.

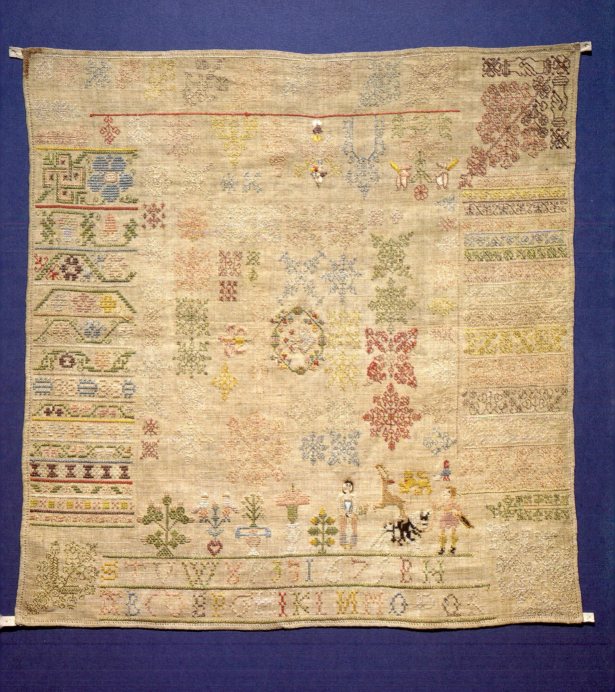

BAND SAMPLER

*Linen. Embroidered with polychrome silks in cross,
back, and satin stitch. Edges finished with buttonhole stitch.
18 × 32 cm. T. 93–1938.*

This dated sampler is one of a group worked towards the end of the seventeenth and into the eighteenth century which are characteristically embroidered with light, bright silks, have buttonholed edges and a distinctive and quite limited range of motifs. The most popular are the Instruments of the Passion, a wreath enclosing an inscription or an armorial bearing, an orange tree and a lemon tree in pots, and an elaborate flower vase. Vavassore published such a vase pattern in *Esemplario di Lavori*, Venice, 1532, and it was used and embellished over two centuries for all types of embroidery and lace. The Instruments of the Passion are usually linked to the Catholic faith.

Unlike the patterns and motifs, the arrangement of horizontal bands does not seem to be continued into the eighteenth century. Nor are the bands used for repeat patterns and inscriptions as they are on English samplers of a similar date. Apart from one floral and one geometric repeat pattern and a complete alphabet, the horizontal divisions are used for different pictorial or design themes, all finely worked, the stitches accurate but with little variety. Whereas the inscriptions on English samplers reflect a Protestant society inculcating its young with religious sentiment based on the Old Testament, the prayer-book, and other morally uplifting texts, Catholic Europe, fired by the Counter Reformation, particularly venerated the Sacred Heart of Jesus and the Crucifixion. A similar sampler of 1683 in the Cooper Hewitt Museum, New York, is believed to come from Bohemia, a Catholic region of the German-speaking world.

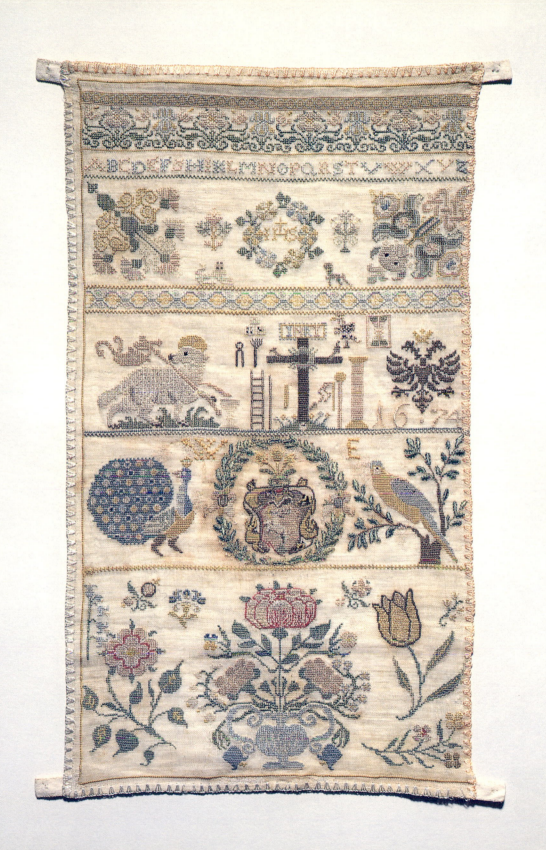

SAMPLER

GERMAN, 1682

●

*Linen. Embroidered with polychrome
silks in cross stitch. All edges hemmed.
22.5 × 42.25 cm. T. 94–1938.*

This sampler makes an interesting comparison to the German, probably
Bohemian, sampler of 1674. The band format has almost disappeared apart
from four small repeat patterns worked across part of the width matched by
an alphabet and the inscription 'MBH 1682' worked across the remainder.
Otherwise the pictorial elements are contained within two sections. There are
no religious references, and the dominant pattern is the elaborate flower vase
surrounded by floral sprigs and two corner motifs. The small section includes
a simple wreath, flower, and bird motif with an orange- and a lemon-tree in
substantial pots to either side. Some parts of the design are rather difficult to
decipher because much of the black silk has disintegrated, leaving the potted
trees without trunks or branches, and very little but stitch holes remain of one
of the birds. As with the other German sampler, the decorative motifs are
straightforward interpretations of popular printed patterns, rather different
from the greater individuality and spontaneity so often found on the mixed
and pictorial band samplers of late seventeenth-century England.

A note that accompanied the sampler reads 'Bought at Nuremberg' and
'Friesland?' The fact that it was bought at Nuremberg gives added weight to a
Bohemian provenance, although a suggested origin in the Friesland Islands
is understandable but unlikely. The Dutch and German Friesland Islands
have a repertoire of patterns which include corner motifs, the flower vase,
and wreaths, but they also have a style of lettering that has not yet been found
to be based on any of the early pattern books. They are also usually wide and
narrow rather than long and narrow, and embroidered with strong, darkish
colours. Gothic lettering and the length of this sampler, as well as a range of
light, coloured silks, point to Central rather than Northern Europe as the area
of origin.

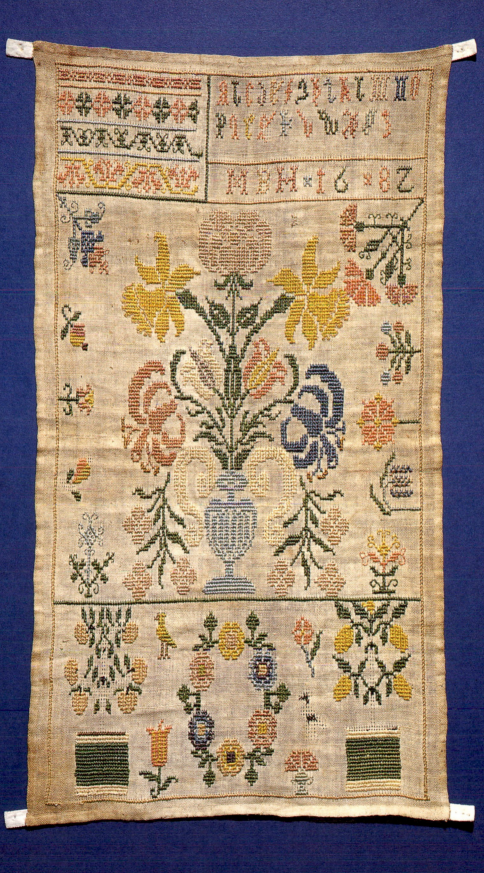

TWO RELATED BAND SAMPLERS

ENGLISH, 1700 AND 1709

—

Linen. Embroidered with polychrome silks in cross,
eyelet, double running, rococo, satin, and stem stitch with
some detached filling stitches on the later sampler. Each has three
sides hemmed with some fragmentary red stitching on that
of 1709, selvedge at top edges. 14.25 × 36.25 cm.
T. 7–1952. 16 × 37.5 cm. T. 106–1928.

These two samplers are both inscribed with the 'larning' verse that appears on the group of three related seventeenth-century samplers, already discussed (no. 12). There is also reference to Iudeth Hayle. Prisca Philips finished her sampler on 'IVNe THe 7 1700' and included the note 'IVDeTH HAYLe / WAS MY MIST / RIS' and followed this with an alphabet. A band of repeat floral patterns is substituted for the alphabet on Mary Moyse's work completed on 'AVGVST THE 11 1709 AGeD 13'. The lower sections of both samplers have similar flowerpot and heart motifs with panels containing the makers' initials, the earlier flanked by the initials of 'IVDETH HAYLE'. In addition, that of 1700 has several small detached motifs, that of 1709 a further 'MM' and, more mysteriously, 'RT' and 'hH'.

Two other samplers are known to exist which are stylistically very close to the two illustrated. One was acquired by the Philadelphia Museum of Art in 1990. Worked by an Elizabeth Burton, it is, in fact, two samplers which belong together and when joined make a coherent whole. Together they display the characteristics of the 'Hayle' samplers, the verse, the initials within a panel, the familiar detached motifs, and the date 1701. In 1710 Elisabeth Goodday completed her sampler which also included the large initials 'RT', as on Mary Moyse's sampler of 1709. The Goodday sampler is part of the National Trust's Goodhart Bequest at Montacute House. Research by Edwina Ehrman of the Museum of London has established that all the names are associated with landed families of the Ipswich area. Iudeth Hayle, the 'dame', presumably came from a humbler background and little has been discovered about her. The reference to 'RT' and 'hH' is a further puzzle to solve. These samplers prove that as far back as the late seventeenth and early eighteenth centuries influential teachers gave to their pupils a quite recognisable style of work.

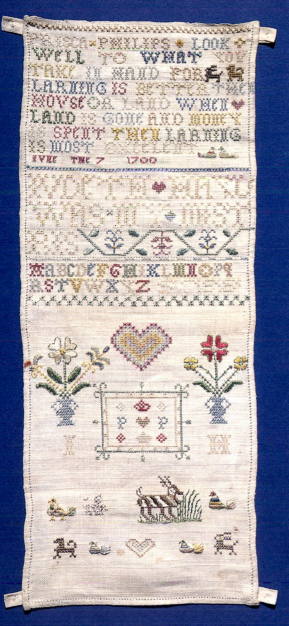

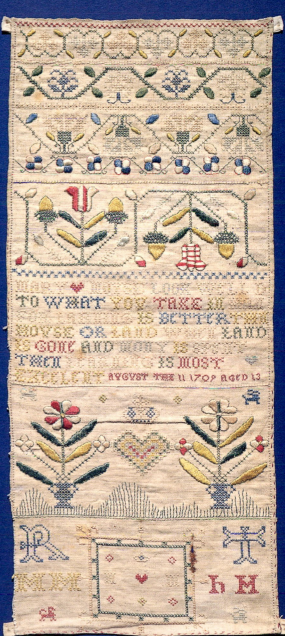

BAND SAMPLER

＊

Linen. Embroidered with polychrome silks in
cross, eye, satin, and rococo stitch. Three edges hemmed,
bottom buttonholed. 21.25 × 46.25 cm.
T. 112–1928.

In contrast to seventeenth-century band samplers, Susanna Savin has worked hers in typically early eighteenth-century fashion with the inscription dominant. The five bands of repeat floral patterns are less complex in design with less stitch variety than earlier work. The clear light colours selected are also typical of taste in the decades around the turn of the century. Sixteen bands are filled with improving verses, the first one being almost identical to that found on the Judeth Hayle samplers. The second verse reads:

SARVe GOD ThAT MA | De YOU WHILST YOV HAVe | YOVR BReATH HONOVR YO | VR PAReNTS DeAR VNTILL | TheIR DeATH IN DOING SO Th | OVLT HAPPY Be ALWAYS OB | TAINING RICHeS HeALTh AND LeNGTh OF D | AYS A BLeSSING IS LAID VP FOR SVCh IN STO | Re IN eNdLeSS BLISS WheN TIMe ShALL Be NO | MORe SVSANNA SAVIN HeR SAMPLER 1716

Susanna Savin made another sampler of similar size, now very faded, but with inscription only and no decorative bands. She also worked a set of numerals on it, but failed to date this exercise. Being very similar in style and quality, it was probably made about 1716. Other pairs of inscribed samplers are known to exist, for example those of Mary Taylor dated 1748 and 1749, part of the Goodhart Bequest to the National Trust. They include the Lord's Prayer and the Apostles Creed, as well as an alphabet and numerals. Contemporary verses of a morally uplifting nature were an increasingly popular choice to accompany or replace familiar prayers and extracts from the Bible. Such books as Dr Isaac Watts *Divine and Moral Songs for Children*, first published in 1720, exemplified the religious fervour of the age. The inscribed sampler demonstrates the decreasing importance attached to stitching techniques, and the greater emphasis on female literacy combined with the virtuous ideas expounded by those such as Isaac Watts and John Wesley.

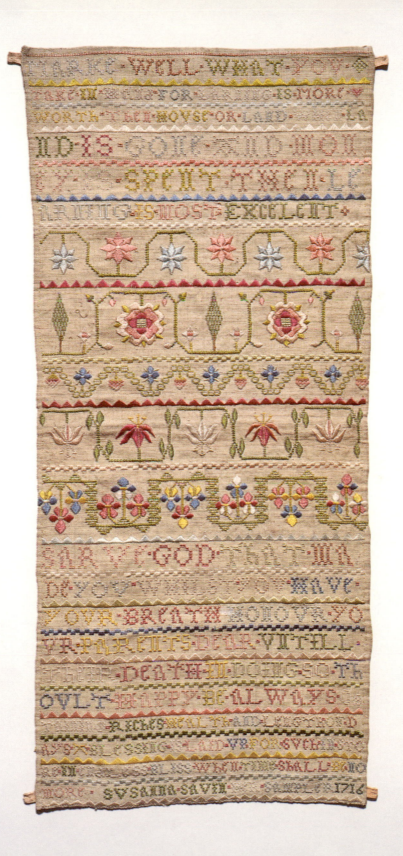

MARKE WELL WHAT YOU
TAKE IN HAND FOR LARING IS MORE
WORTH THEN HOVSE OR LAND LA
ND IS GONE AND MON
EY IS SPENT TWEN LE
ARING IS MOST EXCELENT

SARVE GOD THAT MA
DE YOV WHILST YOV HAVE
YOVR BREATH HONOVR YO
VR PARENTS DEAR VITELL
THEE DEATH IN DOING SO TH
OV MAY HAPPY BE ALWAYS
RICHES WEALTH AND LIFE TO END
AYS BLESSING LAID VP FOR SVCH AS
BLISS WHILE THE SMALL NO
MORE SVSANNA SAVER SAMPLER 1716

BAND SAMPLER

ENGLISH, 1720

—

Wool. Embroidered with polychrome silks in cross,
long-armed cross, herring bone, satin, rococo, Florentine, and
trellis stitch. Two edges hemmed, selvedge at top and bottom.
22.25 × 31.25 cm. T. 15–1950.

The muted shades of this sampler are the result of fading and not the chosen palette of the maker. The strong bright colours that she chose can still be seen on the back of the work. This sampler's debt to the seventeenth century is displayed by the vivid colours, the variety of stitches, and the use of repeat pattern bands with their familiar stylised flower and leaf motifs. There are also several particularly eighteenth-century qualities. The use of wool as a ground cloth, a much less robust material than linen because of the likelihood of moth damage, appears to have gained in popularity from the early part of the century. Of course, earlier wool ground samplers may simply have failed to survive. The gradual change in shape witnessed from the seventeenth to the eighteenth centuries is represented by this sampler. The long and narrow format of earlier work evolved into a more even rectangle, a shape suitable for framing and displaying on the wall: this sampler has damaged edges and faded colours, directly attributable to being mounted and exposed to light. Lastly there is a greater emphasis on informative inscription, typical of the eighteenth century. As well as three alphabets there is a verse. 'ALL FLeSh IS LIke the WIthered Hay | aNd SO It SPrINgs ANd Fades AWay.' The final lines are 'DOrCaS Haynes her WOrk FINIshed the | 25 day of the TWeLVes Month 1720'.

Dorcas Haynes' sampler was passed down through her Quaker family until the mid twentieth century. From the records of the London and Middlesex Quarterly Meeting registers of births and marriages it is known that Dorcas was born on the 4th of January, 1710, in Bermondsey, to Thomas and Hannah. Her marriage to Richard Adams, also of Bermondsey, is recorded on the 23rd of August, 1729. Despite her background, Dorcas' sampler is not embroidered with patterns and motifs associated with Quaker work; these seem to develop within Quaker schools later in the century.

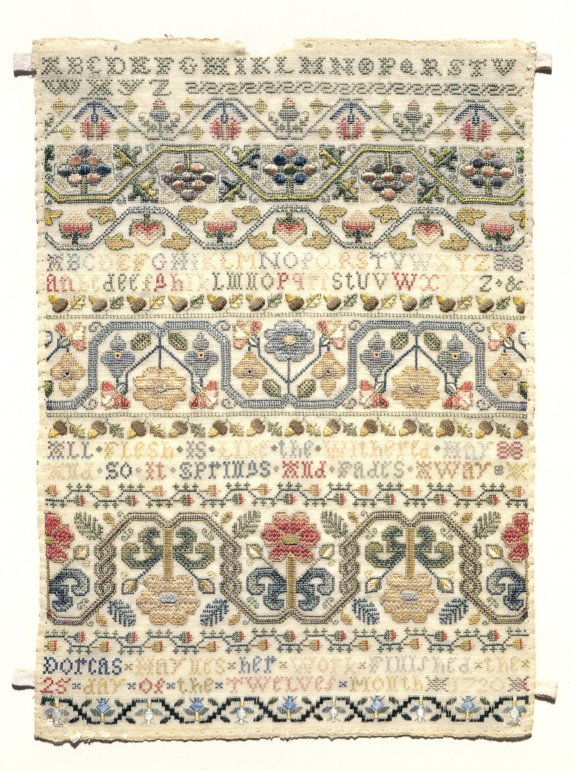

BAND SAMPLER

ENGLISH, 1723

*Linen. Embroidered with polychrome silks in cross,
eyelet, satin, and double running stitch. Three edges hemmed,
selvedge at bottom. 23 × 46 cm. T. 124–1928.*

The bands of inscription on this sampler are typical of the period, but the precise stitching, pattern, and pictorial bands are reminiscent of seventeenth-century work. The swans are probably derived from a design in Sibmacher's book, first published in 1597. The anchor with the initials 'SCD' is the insignia of the St Clement Dane Charity Schools. Two schools were founded at the beginning of the century, in 1701 for foundling boys and a year later for girls. St Clement was the patron saint of seamen; thus suitable boys were trained for service at sea. All pupils were taught basic literacy and numeracy and given religious instruction. In addition, the girls were expected to achieve high standards of sewing and knitting. Pupils wore a distinctive uniform, blue jacket and corduroy trousers for boys, checked dress and cape for girls. The two more formally dressed figures on the sampler probably represent the Master of the Boys' School and the Mistress of the Girls' School. As well as the inevitable alphabet and numerals there are four separate inscriptions:

MARY DEROW OF / THE CHARITY SCHOOL OF ST. CLEMENTS DANES AGED / TEN YEARS BEGVN THIS SAMPLEER AVGVST THE / TWENTY NINTH ANNO DOM 1723.

HE THAT GIVETH TO THE / POOR LENDETH TO THE / LORD AND HIS REWARD / WILL BE IN HEAVEN.

BE NOT WISE IN THEN OWN EYES / FEAR THE LORD AND DEPART / FROM EVIL.

A GOOD NAME IS BETTER THAN / PRECIOVS OINTMENT.

Other similar, though not identical, samplers exist. One was presented to the school this century; another, dated 1712, has recently been auctioned in London. The latter carried the heartfelt inscription: '*This I have done I thank my God without the / Correction of the rod Elizabeth Clements.*'

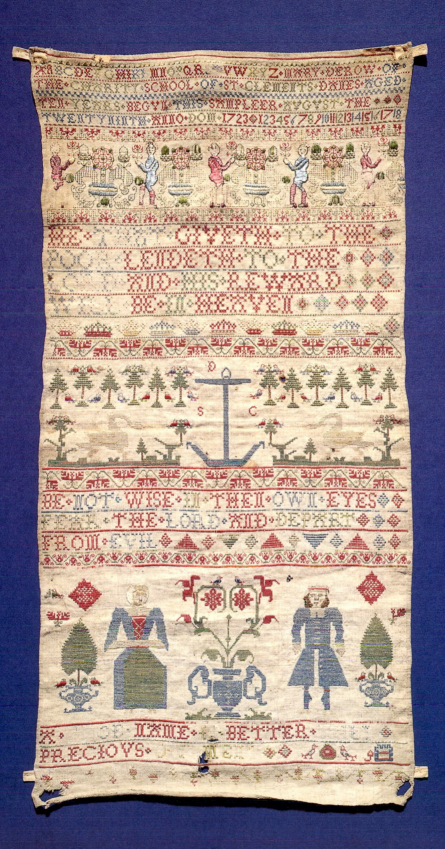

BAND SAMPLER

ENGLISH, 1717

—

Linen. Embroidered with polychrome silks in cross,
long-armed cross, eyelet, Florentine, rice, and chain stitch.
Three edges hemmed, selvedge at bottom. 20.75 × 45.75 cm.
T. 114–1928.

This sampler exhibits many of the characteristics of what was a transitional period for such work. Not quite as long and narrow as the majority of seventeenth-century samplers, it is far from being the rectangular shape suitable for framing. It carries no pictorial content, and is arranged in horizontal bands, but inscription has largely replaced the earlier repeat pattern bands, apart from some very small-scale ones. Although occasionally found on seventeenth-century samplers, the relatively large-scale bands of Florentine stitch are a more usual feature of eighteenth-century work. The characteristic wavy patterns had traditionally been used on hangings and covers, but their popularity was boosted by the development of upholstered furniture, hence their more widespread use on samplers by young girls who would almost certainly devote some of their life to producing embroidered upholstery. On this sampler, Florentine stitching is also worked to frame the main area of inscription, another hint of the move towards the rectangular sampler with a neat, enclosing border destined for frame rather than work box.

As well as one complete and two incomplete alphabets, there is part of a verse which reads: 'O THOV To WHOM ANGeLS | THeIR HYMNS ADDReSS To | WhOM All KNeeS MuSt BOW | ALL TOngueS COnFeSS I ha | Ve OFFended GOd Where Sha | LL I FLY TO hIde MYSeLF Fr | OM hIS OFFended EYe IF RO | .' In a lower band there is the date 1717 and the names 'EdWard BaCheLeR' and 'Ruth BaCheLeR'. It could be assumed that both children sewed the sampler, but it is more likely that it is the work of one hand, as the quality and style of the stitching is quite consistent. Ruth may simply have been recording the name of her brother, and perhaps the initials within the coronets record other members of her family. The crowns and coronets found on eighteenth-century samplers were predominantly seen as just another pattern-motif, and rarely signified noble rank.

ABCDEFGHI KLMNOP RSTUV
ABCDEFGHIKLII
PQRSTVWXYZ

1717

BORDERED SAMPLER

ENGLISH, 1735

—

Wool. Embroidered with polychrome silks in satin,
cross, marking cross, eyelet, stem, split, and chain stitch.
Two edges hemmed, selvedge with double blue lines at
top and bottom. 27 × 30 cm. T. 9–1952.

This almost square sampler is framed by a densely worked border of a highly stylised flower-head and leaf pattern. Although the arrangement of horizontal bands is reminiscent of the previous century, their contents are typically eighteenth century. The only pictorial decoration is a mixture of traditional stylised flowerpot motifs and more naturalistic birds and tulips. The remainder of the decoration is almost all lettering, with three alphabets, including one of grouped letters, numerals, the Lord's Prayer worked entirely in red, two further inscriptions, and finally 'ELIZABETH RAWLINS HER WORK FINISHED May ye 22 1735'. Crowns, coronets, hearts and other small motifs fill any remaining spaces.

The two verses are arranged correctly with no split words or lines and read:

CONTENT IS THE CHIEFEST TREASURE OF THE MIND
AND HAPPY THOSE SO SURE A BLESSING FIND
IT IS THAT GIVES REAIL WORTH TO ALL WE HAVE
WITHOUT CONTENT MANKIND IS A GENERAL SLAVE

and:

FANCY THOU BUSY OFFSPRING OF THE MIND
THOU ROVING RAINGING RAMBLER UNCONFINED
RESTLESS THY SELF WONT LET POOR ME ALONE
THOU SOMETHING NOTHING ANY THING IN ONE

A very similar, privately owned sampler dated 1740 is illustrated in Averil Colby's book, *Samplers*, Fig. 106. Worked by a Mary Whitehead, it is fractionally larger and has a single different inscription apart from the Lord's Prayer. But the borders, the bird and flower bands, and the grouped alphabets are all very much alike. On grounds of style and content, it seems likely that the two samplers are linked by a common teacher or school, although no initials or name are included on the work to give support to this theory.

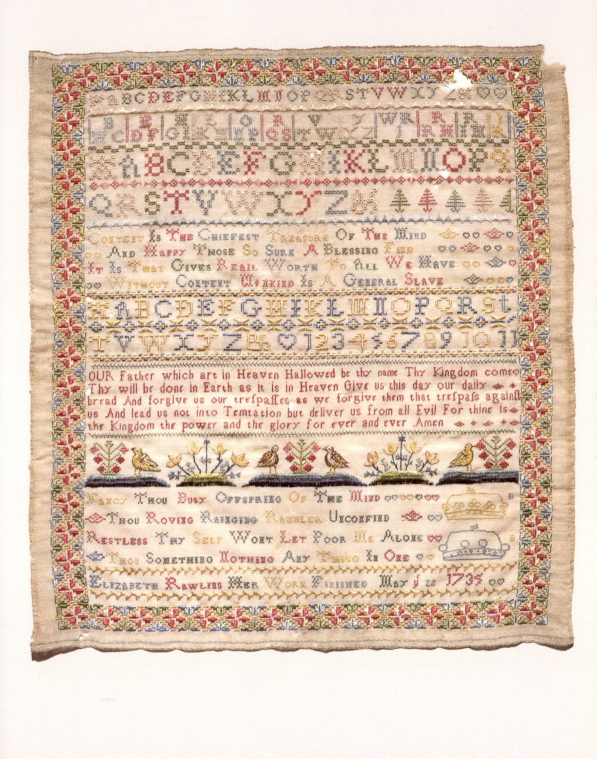

CONTENT IS THE CHIEFEST TREASURE OF THE MIND
AND HAPPY THOSE SO SURE A BLESSING FIND
IT IS THAT GIVES REAL WORTH TO ALL WE HAVE
WITHOUT CONTENT MANKIND IS A GENERAL SLAVE

OUR Father which art in Heaven Hallowed be thy name Thy Kingdom come
Thy will be done in Earth as it is in Heaven Give us this day our daily
bread And forgive us our trespasses as we forgive them that trespass against
us And lead us not into Temtation but deliver us from all Evil For thine is
the Kingdom the power and the glory for ever and ever Amen

FANCY THOU BUSY OFFSPRING OF THE MIND
THOU ROVING RANGING RAMBLER UNCONFIND
RESTLESS THY SELF WONT LET POOR ME ALONE
THOU SOMETHING NOTHING ANY THING IN ONE

ELIZABETH RAWLINS HER WORK FINISHED May y 22 1735

SAMPLER

ENGLISH, 1755

—

*Wool. Embroidered with polychrome silks
in cross stitch. Side edges hemmed, top and bottom
fragmentary selvedge with double blue line.
22 × 31.75 cm. T. 155–1928.*

Samplers with a woollen canvas ground frequently show moth damage. This one has considerable areas of loss and some of the embroidery is also incomplete. Many small leaves and flowers near the inner margins of the floral frame are unworked and are only visible as faint outlines. Despite these problems, the flowing, naturalistic, colourful border is unlike the conventional discreet patterns usually found on eighteenth- and nineteenth-century samplers, and very much more like contemporary canvas work embroidery, used prolifically on upholstery, screens, cushions, bags, etc. Perhaps 'Mary Nickolls Exton' who 'Finiſhed | This work March yᵉ 20 | Anno Domini | 1755' made her sampler for the old fashioned purpose of providing a prototype for future embroidery projects.

The Lord's Prayer and two verses from *The Morning Song*, taken from Dr Isaac Watts' *Divine and Moral Songs for Children*, are arranged within the border. Unlike most of the inscriptions found on earlier samplers, a deliberate attempt has been made to arrange the verse in proper linear order. Instead of the usual neglect of scansion, only the first line of the second verse fails to fit the available space. The careful arrangement of the sampler and the use of one type of stitch, cross stitch, indicates a growing stress on the literary element of the sampler and the redundancy of a stitching repertoire in an age devoted to the simpler techniques of canvas work embroidery.

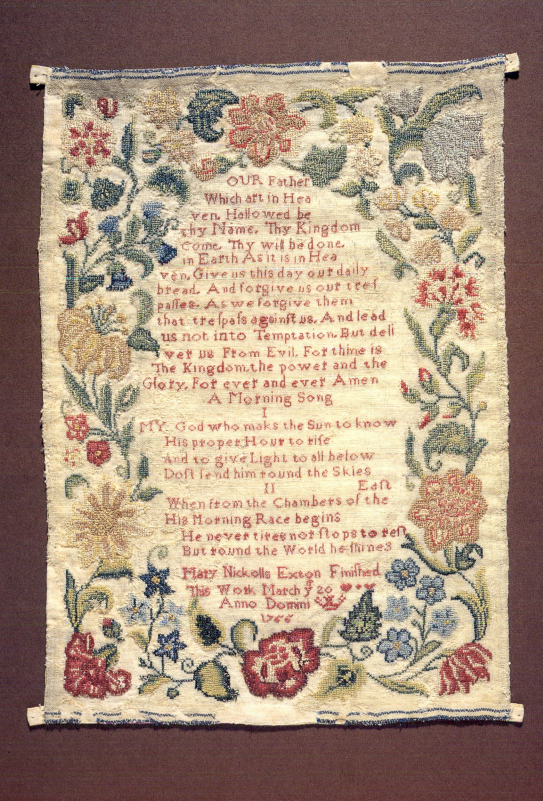

OUR Father
Which art in Hea
ven. Hallowed be
thy Name. Thy Kingdom
come Thy will be done.
in Earth As it is in Hea
ven. Give us this day our daily
bread. And forgive us our tref
paffes. As we forgive them
that trefpafs againft us. And lead
us not into Temptation. But deli
ver us From Evil. For thine is
The Kingdom the power and the
Glory. For ever and ever Amen
A Morning Song
I
MY God who maks the Sun to know
His proper Hour to rife
And to give Light to all below
Doft fend him round the Skies
II Eaft
When from the Chambers of the
His Morning Race begins
He never tires not ftops to reft
But round the World he fhines

Mary Nickolls Exton Finifhed
This Work March ÿ 20
Anno Domni
1766

'TABLET' SAMPLER

FRENCH OR CHANNEL ISLANDS, 1743–1744

Linen. Embroidered with polychrome silks in cross and satin stitch. Three edges hemmed, selvedge at bottom. 42 × 64.5 cm. T. 176–1928.

Samplers inscribed with the Lord's Prayer, a Creed, or the Ten Commandments became increasingly popular in England from the 1720s. Their format was similar to the painted boards displayed in churches of the day, with the appropriate religious tract set out for the education of the congregation. The combination of moral edification and instruction in stitching was embraced enthusiastically by governesses and schoolteachers.

The fervent evangelism of Dr Isaac Watts, John Wesley, and their contemporaries profoundly influenced education in the English-speaking world on both sides of the Atlantic. This trend is well illustrated by the increase in morally uplifting inscriptions on eighteenth-century samplers.

To find the Ten Commandments worked in tablet form in French seems doubly anachronistic. Firstly, one of the major differences between English and Continental samplers is the prevalence of inscription on the former, and the almost complete absence of it on the latter, apart from alphabets, initials, or name and a date. In addition to the Commandments, the following is worked: 'Fait par moi Magdeleine Breillat / Agée de huit ans et 3 mois 1743–4' (Made by me Magdeleine Breillat / Aged eight years and 3 months 1743–4). Secondly, it seems unlikely that a French Catholic girl would have been familiar with the painted boards of the Church of England.

Another earlier sampler of 1724, with a similar arrangement of the Ten Commandments in French, has been tentatively attributed to the Channel Islands. Strangely, the museums of Jersey and Guernsey do not have any similar samplers, and only a tiny minority of their collection is inscribed in French rather than English. Furthermore, the names Breillat and Guimon (on that of 1724) are not thought to be typical of Island families. Possibly Magdeleine Breillat came from a Protestant French family who sought refuge in the Channel Islands, where the French language has always been entwined with English traditions. This sampler may well be the product of such a mixed cultural and religious background.

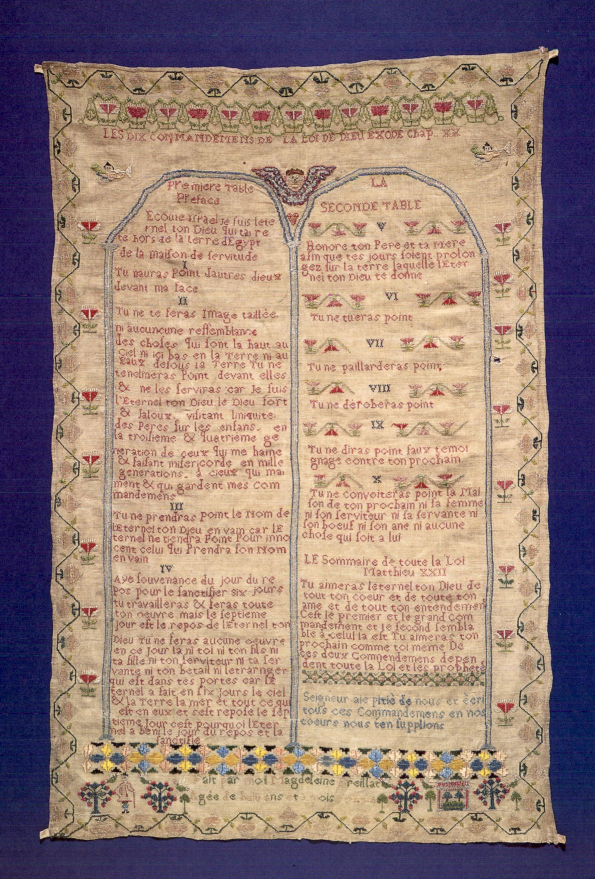

LES DIX COMMANDEMENS DE LA LOI DE DIEU EXODE Chap. XX

Premiere Table
Preface

Ecoute Israel je suis l'ete
rnel ton Dieu qui t'a re
te hors de la terre d'Egypt
de la maison de servitude
I
Tu n'auras Point d'autres dieux
devant ma face
II
Tu ne te feras Image taillée.
ni aucun[e] ne ressemblance
des choses qui font la haut au
ciel ni ici bas en la Terre ni au
Eaux dessous la Terre Tu ne
t'enclineras Point devant elles
& ne les serviras car Je suis
l'Eternel ton Dieu le Dieu fort
& jaloux. visitant l'iniquite
des Peres sur les enfans. en
la troisieme & quatrieme ge
neration de ceux qui me haine
& faisant misericorde en mille
generations. à ceux qui m'ai
ment & qui gardent mes com
mandemens
III
Tu ne prendras point le Nom de
l'eternel ton Dieu en vain car l'e
ternel ne tiendra Point Pour inno
cent celui qui Prendra son Nom
en vain
IV
Aye souvenance du jour du re
Pos pour le sanctifier six jours
tu travailleras & feras toute
ton oeuvre mais le septieme
jour est le repos de l'Eternel ton
Dieu Tu ne feras aucune oeuvre
en ce jour la ni toi ni ton fils ni
ta fille ni ton serviteur ni ta ser
vante ni ton betail ni l'etranger
qui est dans tes portes car l'e
ternel a fait en six jours le ciel
& la terre la mer et tout ce qui
est en eux et s'est repose le sep
tieme Jour c'est pourquoi l'Eter
nel a beni le jour du repos et la
sanctifie

LA
SECONDE TABLE

Honore ton Pere et ta mere
afin que tes jours soient prolon
gez sur la terre laquelle l'Eter
nel ton Dieu te donne
VI
Tu ne tueras point
VII
Tu ne paillarderas point
VIII
Tu ne deroberas point
IX
Tu ne diras point faux temoi
gnage contre ton prochain
X
Tu ne convoiteras point la Mai
son de ton prochain ni sa femme
ni ton serviteur ni sa servante ni
son boeuf ni son ane ni aucune
chose qui soit a lui

LE Sommaire de toute la Loi
Matthieu XXII
Tu aimeras l'eternel ton Dieu de
tout ton coeur et de toute ton
ame et de tout ton entendemen
C'est le premier et le grand Com
mandement et le second sembla
ble a celui la est Tu aimeras ton
prochain comme toi meme De
ces deux Commendemens depen
dent toute la Loi et les prophete

Seigneur aie pitié de nous et ecri
tous ces Commandemens en no
coeurs nous t'en supplions

ait par moi Magdeleine reillat
gée de huit ans et...mois

COMMEMORATIVE SAMPLER

ENGLISH 1759

Wool. Embroidered with polychrome silks in cross and satin stitch. Two edges hemmed, selvedge with double blue lines each side. 32 × 33 cm. T. 1–1944.

A double carnation border frames symmetrically arranged spot motifs placed either side of the inscription. Two pairs of the motifs relate to, Charles II. On either side of the title are two oak trees holding a crowned head of Charles II, a traditional reference to the Boscobel Oak and the events of the Civil War, already noted on a sampler dating from the 1660s (no. 10). Immediately below, another pair of oak trees each shading two figures which appear to be crowned, presumably represent another expression of Royalist sentiment. Mourning and memorial samplers started to become popular in the mid-eighteenth century and this, with an encomium in black silk, seems to be part of that fashion, albeit worked a century after the Civil War and Restoration. The full inscription addressed to Charles I reads:

AN ENCOMIUM
of that ever Bleſſed Martyr
King Char. the 1ſt
Dedicated to all true Lover's
of CHURCH and MONARCHY.

Great Charles thou earthly God Cæleſtial man,
Whoſe Life like others (al tho') yet a Span,
Yet in that Span was Comprehended more
Then Earth have Waters of the Ocean Shore.
Thy heavenly Virtues Angels ſhould rehearſe
It is a Theam too high for humane Verſe
Yet on this Subject I am fully bent
If God Direct me to be Eloquent, look
He that would Know Thee well, let him but
Upon thy moſt Incomparable Book
And read Thee (o'or and o'er) which if he do
He'll find Thee King and Prieſt and Prophet too
O Cruel hardhearted Rebels that cou'd
Cut down that Stately Cedar, whilſt it ſtood
Which was the Cheifeſt Glory of the Wood
But now Royal Martyr, thou art for ever blest
With Endleſs Joys, and Everlaſting Reſt
Crown'd with a Diadem of Glory there
Bright are ſuch Crowns that bleſſed Martyrs wear.
Thy Death, Thy ſufferings let no Man Name,
It was thy Glory. but the Kingdoms Shame
 Sarah 1759 Robertson.

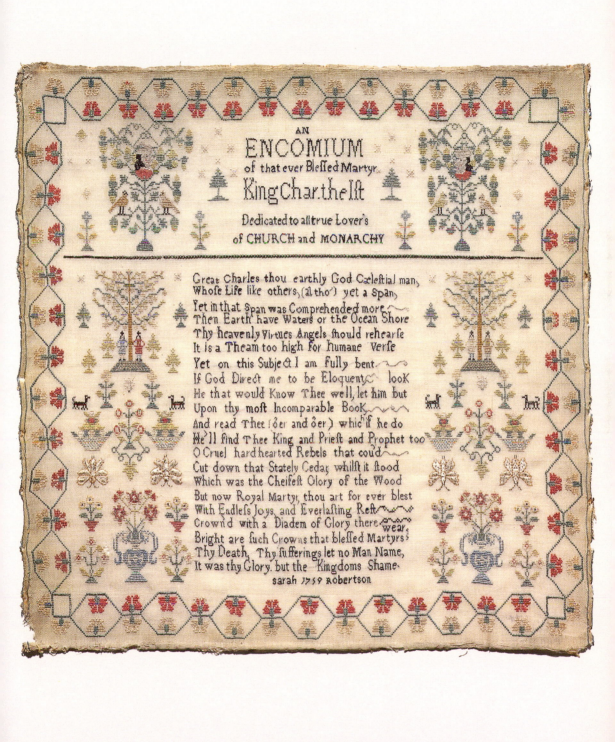

AN
ENCOMIUM
of that ever Blessed Martyr

King Char. the Ist

Dedicated to all true Lover's
of CHURCH and MONARCHY

Great Charles thou earthly God Cælestial man,
Whose Life like others, (al tho') yet a Span,
Yet in that Span was Comprehended more
Then Earth have Waters or the Ocean Shore
Thy heavenly Virtues Angels should rehearse
It is a Theam too high for humane Verse
Yet on this Subject I am fully bent
If God Direct me to be Eloquent; look
He that would Know Thee well, let him but
Upon thy most Incomparable Book
And read Thee (öer and öer) which if he do
We'll find Thee King and Priest and Prophet too
O Cruel hard hearted Rebels that coud
Cut down that Stately Cedar whilst it stood
Which was the Cheifest Glory of the Wood
But now Royal Martyr, thou art for ever blest
With Endless Joys, and Everlasting Rest
Crown'd with a Diadem of Glory there wear,
Bright are such Crowns that blessed Martyrs
Thy Death, Thy sufferings let no Man Name,
It was thy Glory. but the Kingdoms Shame
sarah 1759 robertson

BORDERED SAMPLER

ENGLISH, 1792

Wool. Embroidered with polychrome silks in cross, satin, and stem stitch. Edges bound with pink ribbon, the whole backed with cotton sateen, all of a later date. 32.75 × 44 cm. T. 42–1938.

A conventional strawberry border frames a sampler of free-style embroidery with the pictorial element worked in a needle painting technique. The ribboned baskets, delicate rosebuds, and the pastoral scene reflect the decorative fashion of the time. The use of paper figures with painted features, applied to the ground fabric by some of the stitches that are used to create the effect of costume, was also a contemporary practice. Prepared and painted figures were widely available and used in many embroidered pictures and small furnishing items such as screens.

The inscription within a wreath tells us that 'Mary Brooks / Finish'd this ſampler / in the Year 1792.' Mary Brooks also illustrated the verses worked within the central panel with a beehive and a modest swarm of bees mingling with the flowers and butterflies. The verses are a transcription of Song 20 from Dr Isaac Watts' *Divine and Moral Songs for Children*, first published in 1720, constantly reprinted, and still in use in the nineteenth century. The title given to the song in the book is 'Against Lateness and Mischief'. The song is not correctly arranged on the sampler and reads as follows:

How doth the little busy bee
Improve each ſhining hour, And gath[er]
honey all the day From every open
flower:

How ſkilfully ſhe builds her cell. How
neat ſhe ſpreads the wax: And labours
hard to ſtore it well, With the ſweet
food ſhe makes. In works of labour or
of ſkill I would be busy too; For

ſatan finds ſome miſchief ſtill For idle
hands to do. In book[s,] or work, or healt
hful play, Let my first years be paſt,
That I may give for every day,
Some good account at laſt.

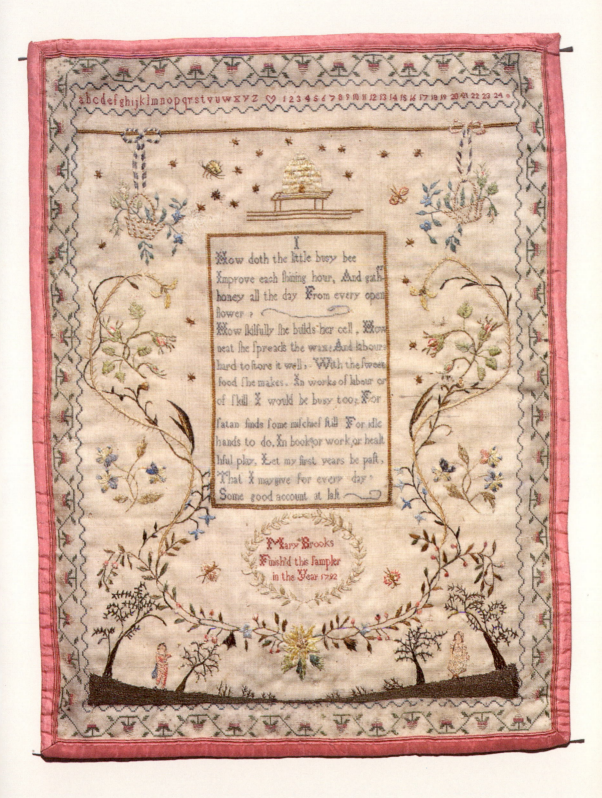

abcdefghijklmnopqrstuvwxyz ♡ 1 2 3 4 5 6 7 8 9 10 11 12 13 14 15 16 17 18 19 20 21 22 23 24 .

I
How doth the little busy bee
Improve each shining hour, And gath
honey all the day From every open
flower ;
How skilfully she builds her cell, How
neat she spreads the wax, And labours
hard to store it well, With the sweet
food she makes. In works of labour or
of skill I would be busy too; For
satan finds some mischief still For idle
hands to do. In book or work or healt
hful play, Let my first years be past,
That I may give for every day
Some good account at last

Mary Brooks
Finish'd this sampler
in the Year 1782

FRIENDSHIP SAMPLER

ENGLISH, 1790

Cotton. Embroidered with polychrome silks in cross
stitch. Three edges hemmed, selvedge on right side.
15.25 × 19 cm. T. 165–1928.

The small size, the exclusive use of cross stitch and the theme of the inscription illustrate how much the purpose of the sampler had changed over the centuries. From being an *aide-mémoire* of stitches and patterns, to be added to and kept at hand in a work box or bag, this sampler of the late eighteenth century fulfils the purpose of a twentieth-century greeting card. An inexpensive material and a simple stitch has been used on a small scale that could have been worked in a matter of hours rather than days or months. Commemorative samplers were increasingly popular from the mid-century; gift and friendship samplers were a novelty of the later decades of the century. The simple, cross stitched, familiar motifs of samplers such as this were also used to decorate other small gifts widely exchanged between family and friends, for example needle-cases, letter pockets, and pin-cushions. The inscription reads:

This gift my friend,
To the I. send.
In hope to be approved
I have done my best
I do protest.
For one so well beloved
Mary Sharp to Mary
Limmer June 25 1790

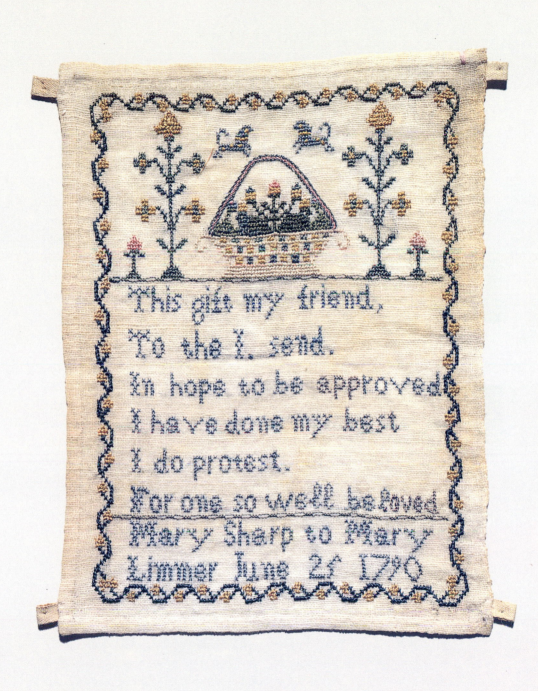

This gift my friend,
To the I. send.
In hope to be approved
I have done my best
I do protest.
For one so well beloved
Mary Sharp to Mary
Limmer June 2ſ 1796

QUAKER SAMPLER

*Wool. Embroidered with black silk
in cross stitch. All edges hemmed, left side a
hemmed selvedge with double black lines.
27.25 × 20 cm. T. 48–1938.*

The border comprises a series of geometric and stylised floral spot motifs which, if worked with their mirror-image, would make a complete design. Within the border there are seven similar whole motifs and a floral spray. There are various inscribed initials and '1799' worked twice within five of these wreaths or lozenge motifs. In addition there is a detached inscription 'M Quertier 1799'. The format of this sampler is not unique. Another, privately owned, was sewn by Eliza Trusted in 1803. She too made a border of half-images, and filled the centre with complete patterns. She used red rather than black silk, but similarly used only cross stitch. The family also owns a knitted pin-cushion decorated with a pattern similar to her sampler pattern with the information on the back 'From Ackworth School.' The stitch count on a cross stitch sampler is not difficult to translate into a simple knitting pattern. The wreath motif enclosing the inscription 'MQ to MN 1799' on the Quertier sampler could easily be worked in either technique. As with the friendship sampler (no. 30) knitted pin-cushions were a popular gift between young women at this time, and were often worked in contemporary sampler patterns.

Quaker families and Quaker schools such as Ackworth in Yorkshire produced distinctive work, favouring particular patterns and forms of lettering. The formality of the patterns and the simplicity of the stitching is typical of eighteenth-century Quaker work. A rather more flamboyant pictorial style developed in the nineteenth century, particularly in North America. With this development the more formal characteristics such as the lettering style and the wreaths tended to perish. The Quertiers were a Quaker family from the Channel Islands, and it is not known whether the children crossed to the mainland to be educated far away at Ackworth, Yorkshire. However similar work seems to have been done by many Quaker girls, who perhaps relied on printed material as well as the traditional motifs passed on by teachers and family.

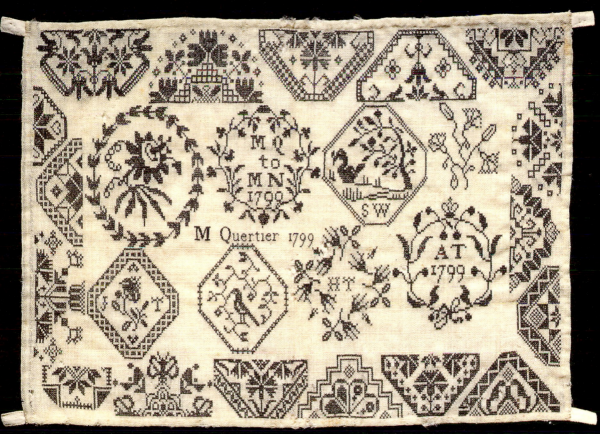

TWO WHITEWORK SAMPLERS

ENGLISH, 1719

Linen. Embroidered with linen and silk threads in buttonhole and chain stitch with drawn thread work and hollie point fillings. Raw edges with remnants of a border pattern and hem on left side. 22 × 24.5 cm. T. 139–1938.

The 1719 sampler has many unusual features. The head and arms of the female figure are backed with tinted paper and stitched with coloured silks to define face, hair and coronet. Inscribed 'MARCH 13 1719 / Iohanna SPeRINCK', the date is plainly English, the name not. The drawn thread work resembles the fine embroidery widely known as Dresden work or *Point de Saxe*, used as a cheaper alternative to lace. From its continental origins it spread to Britain and North America. Hollie point however is very English. Also known as English lace, it was a popular trimming or insertion for infants' clothing and christening sets but was not adopted in Europe. The combination of continental and English whitework techniques with a similarly mixed inscription suggests either a young woman whose family had settled in England or one who has come from the continent to work as a governess.

ENGLISH, 1728

Linen. Embroidered with linen thread in satin and back stitch with hollie point and needle lace insertions. All edges hemmed. 21 × 21.75 cm. T. 136–1928.

The second, almost square, sampler, inscribed 'VRSVLA / SLADE /' is one of several similar ones to be found in various collections. Frequently dated, they usually fall within the 1720s and 1730s. Almost identical work was produced in Pennsylvania, USA, from the 1730s onwards with increasing elaboration of stitch and design. Considerable skill was required to work the inserted panels of hollie point and needle lace neatly divided and bordered by repeat patterns in counted satin stitch. There seem to be too many to attribute to a particular school or teacher. Possibly they were popularised by an eighteenth-century publication at a time when instruction books were increasingly produced to satisfy an expanding education system.

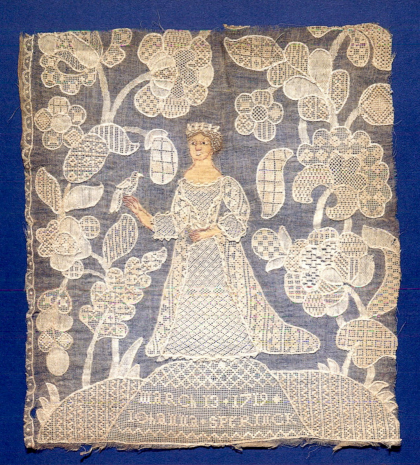

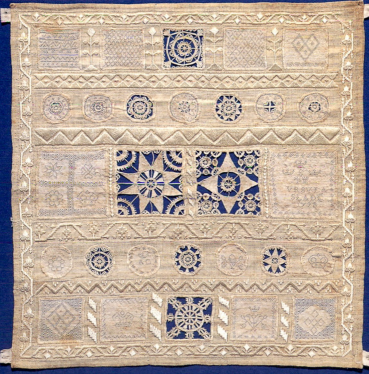

33

TWO WHITEWORK SAMPLERS

•

*Linen. Embroidered with linen in dot, back, and double hem stitch; faded
yellow silk, a minute quantity of black and red silk in back and filling stitch.
All edges hemmed, picots along top. 15 × 29,25 cm. T. 24–1938.*

On this sampler made by Mary Caney in 1710 the stitches, repeat patterns, and
pictorial panel are all unusual. The pastoral scene is simply delineated in back
stitch with some filling stitches. The small, geometric repeat pattern bands
appear to be composed of single, isolated dots, but the reverse shows that
the thread is carried across between stitches, like an exaggerated running
stitch. It has been suggested that the technique was an attempt to simulate
'knotting', a popular applied embroidery of the period. However, the knotted
threads were usually sewn down in continuous flower, foliage and strapwork
patterns, not detached geometric shapes. Possibly the identification and nam-
ing of the stitch led to confusion. True 'dot' stitch has two, not one, threads
per hole, and is sometimes called 'knot' stitch. One of its variations is the
twisted French knot, which gives a raised effect similar to knotting.

•

*Linen. Embroidered with linen thread with a minute
quantity of red silk in satin, chain, buttonhole, double running
stitch and French knots. Three edges hemmed, selvedge at bottom.
17.25 × 42 cm. T. 103–1938.*

Apart from the inscription 'ANNO 1774' and the initials 'IC' surmounted by a
heart and coronet, the sampler is worked with half bands of repeat patterns
predominantly in counted satin stitch or French knots. Where the latter are
used for the geometric repeat patterns there is a striking similarity to those on
Mary Caney's sampler. The patterns no doubt derive from common European
printed sources. The use of dot or knot stitch is most likely coincidental, a
popular decoration on southern German samplers but an oddity on English
work. Bought in Bamberg, the sampler probably comes from Bavaria or
neighbouring Czech Bohemia, areas renowned for their whitework.

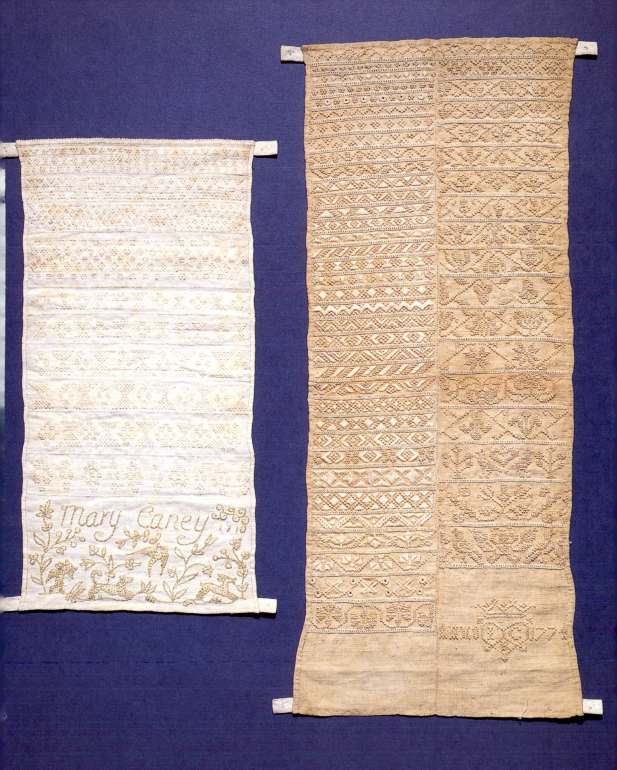

34

BAND SAMPLER

GERMAN, 1719

◦

Linen. Embroidered with linen and polychrome silk
threads in chain, feather, cross, long-armed cross, and whipped
running stitch with French knots. All edges hemmed.
19.5 × 92.25 cm. T. 96–1938.

An alphabet and the inscription 'GRS 1719' divide the more conventionally embroidered bands from those worked exclusively in French knots. A wide band at the bottom is filled with detached flower and bird motifs, two corner motifs, and a pierced heart and coronet within a wreath. Not only do the bands follow the conventional arrangement of increasing depth from top to bottom, but the graduation of bands is emphasised by the use of strengthening colour. Faded on the front, the silks on the reverse change by degrees from pastels to stronger reds, greens, and purples as the work progresses. In addition, more surface texture is given to the familiar repeat border patterns as flat embroidery stitches give way to the French knot. Similar stitches and effects are found on the English sampler of 1710 and the German sampler of 1774 (no. 33). Another unusual feature is the creation of the pattern from the areas left unworked, a technique known as 'voiding'. Cross stitch voided embroidery was a popular technique of domestic embroidery over much of Europe, particularly in Central Europe, Assisi in Italy, and on some Spanish work. Oddly it rarely occurs on samplers, the most notable examples dating to the sixteenth and early seventeenth centuries.

The pierced or Sacred Heart within a wreath is indication of a Catholic provenance. The whitework knotted German sampler of 1774 has been tentatively assigned to Bavaria; possibly this coloured work is also from the southern half of Germany.

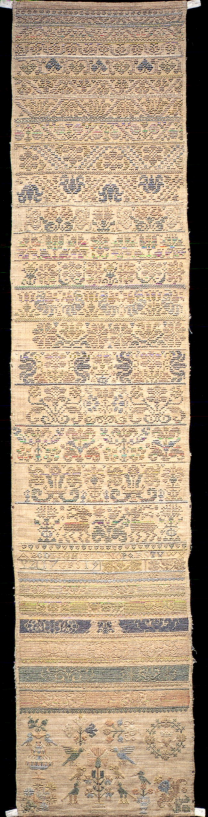

MIXED BAND AND
SPOT MOTIF SAMPLER

DUTCH, 1727

Linen. Embroidered with polychrome silks
in cross, satin, back, eyelet, and running stitch.
Three edges hemmed, selvedge left side.
53 × 32.25 cm. T. 85–1938.

Six incomplete alphabets as well as the initials 'FL' and various space-filling small motifs are worked across the top of the sampler in horizontal bands. Partial bands or repeat patterns appear on the lower half with detached motifs on three sides of a large star shape flanked by the boldly worked initials 'FL'. The date 1727 and numerals 1–10 are inscribed along the lower left edge.

Samplers with a horizontal rather than a vertical emphasis, decorated with rows of alphabets and distinctive patterns in rather bland shades of buff, pink, reddish-brown, and light blues, greens, and yellows are typical of work produced over a large area of northern Europe. There are many similarities of stitching and motif between embroideries of Holland, northern Germany, and southern Scandinavia, although the last usually favoured stronger colours. Dating from the early decades of the eighteenth century, this sampler lacks the pictorial motifs of later work which often give clues as to provenance. A multiplicity of alphabets and the bold initials are typical of embroidery from the province of Friesland, and this derivation is supported by the fact that the sampler was bought in Leeuwarden.

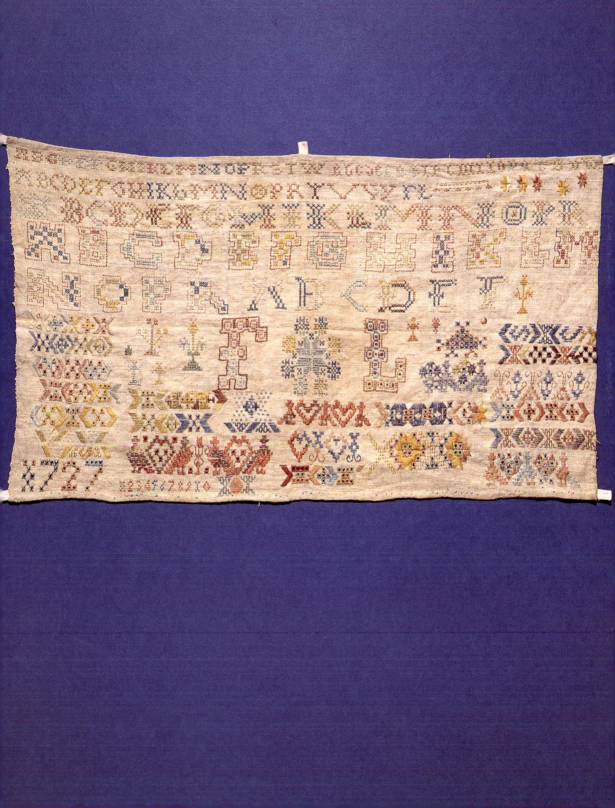

MIXED BAND AND
SPOT MOTIF SAMPLER

DUTCH, 1728

Linen. Embroidered with linen thread in eyelet,
satin, hem, and stem stitch with needle weaving and some
needle lace filling stitches. Pink and green silk worked in eyelet,
satin, cross, and whipped stem stitch. All edges hemmed.
24.5 × 42.75 cm. T. 135–1928.

This dated sampler was bought by Dr Glaisher and believed to be English. There are some visual similarities with the 1710 sampler worked by Mary Caney (no. 33). The bands of small geometric repeat patterns are a feature of both samplers, but the whitework techniques employed are different. The continuing popularity of such patterns has been discussed in the comparison of Mary Caney's work and the German sampler of 1774 (no. 33), and emphasised in this further example of 1728. However, the style of the whitework alphabet and the coloured spot motifs and decorative initials on the lower part of this sampler are not English work, but entirely typical of that produced in the Dutch Friesland Islands. The ornamented hearts, stars and geometric patterns were favoured motifs across Europe, but the lettering is idiosyncratic and particular to the islands off the north coast of Holland. Whereas most alphabets on European samplers are based on those published in pattern books, from the sixteenth century onwards the chunky, decorated form of Friesland lettering seems to have developed as an isolated, local style. Taken to an extreme, the highly decorated, large initials 'H B' more closely resemble a spot motif than lettering. A more typical Friesland sampler of very similar date, 1727 (no. 35) makes an interesting comparison to this less usual combination of two embroidery techniques. A smaller, plainer 'HB' is worked at the bottom of the sampler, as is the date '1728'. Another plainer motif is a small tulip, an unsurprising Dutch favourite. But the ornate, decorative style was not simply an embroidery exercise restricted to samplers; similar complex motifs were worked on such items as dowry kerchiefs and other garments. Lettering, both simple and not so simple, was adapted for marking personal and household linen.

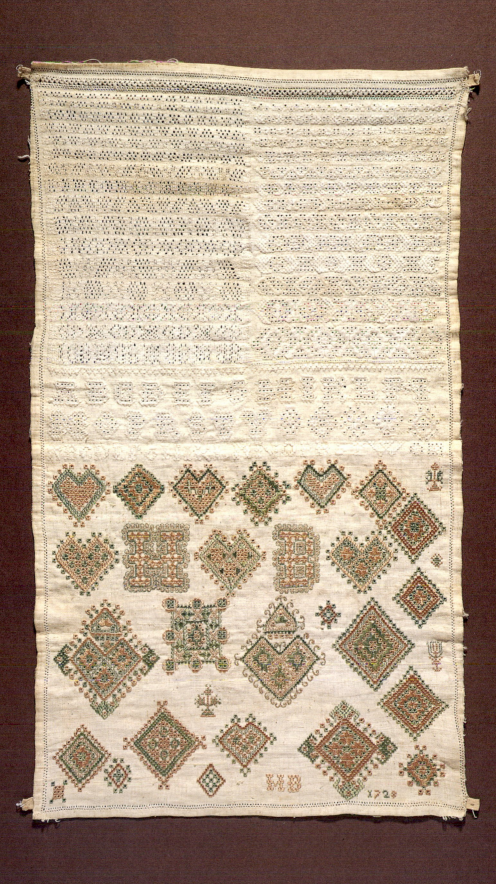

TWO CONTINENTAL SAMPLERS

GERMAN, 1727

Linen. Embroidered with polychrome silks in cross, Florentine,
tent, satin, and rice stitch with a little pulled work. Edges hemmed and
finished with buttonhole stitch. 24.25 × 33.25 cms. T. 97–1938.

Although some fifty years later than no. 18, both are worked on loosely woven linen in a wide range of subtly coloured silks. The quality of the stitching on the later example is coarser and the arrangement of patterns and motifs less strictly determined by horizontal bands. Many of the motifs are similar. There is an additional alphabet and numerals 1–10, and a wreath encloses the initials 'D M' and 'M S' rather than the armorial bearing on the earlier sampler. It is the inclusion of seven blocks of all-over patterns which makes it quite different from the seventeenth-century work. The largest pattern is in Florentine stitch, and the others are in stitches generally associated with canvas work embroidery, a technique that became more popular because of its suitability for use on the increasingly fashionable upholstered furniture. Such a sampler provides an eighteenth-century example of techniques continuing to reflect contemporary embroidery fashion. A very early one of the type, dated 1688, is in the Victoria and Albert Museum's collection and has several almost identical patterns to this of 1727.

DANISH, 1756

Linen. Embroidered with polychrome silks in cross, satin,
Florentine, and tent stitch with a little pulled work. Silver metal thread
laid and couched. All edges hemmed. 34 × 29.5 cm. T. 80–1938.

Although the Danish sampler is worked on a wider panel there are many similarities to the German work. The palette of colours, choice of stitches, and the lettering are little different. But perhaps the most visually obvious link is the blocks of pattern. They emphasise not only the sampler as a record of a popular style of embroidery, but also that such styles crossed national boundaries. The many sets of initials, the wide border pattern of stylised flower heads in a diamond trellis, and the flower baskets are more specifically Danish, a provenance strengthened by the fact of its purchase in Copenhagen in 1906.

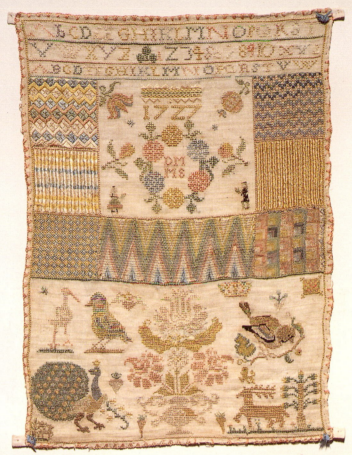

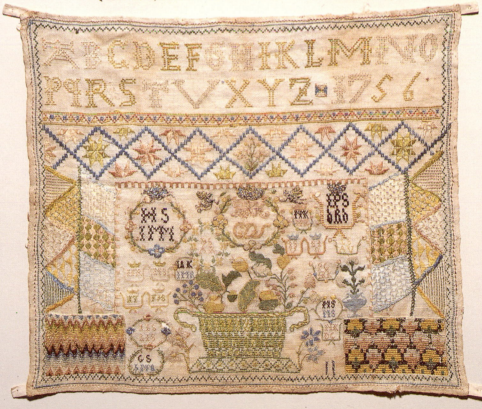

DARNING SAMPLER

DUTCH OR GERMAN,

1739

•

Linen. Embroidered with linen and polychrome
silks in four-sided stitch, pattern or damask darning,
simple and stocking darning. Three edges hemmed,
selvedge left side. 51 × 49.5 cm. T. 86–1938.

Double bands of simple linen darning frame the central inscription of coro-net, initials 'SVDP', and date, 'ANNO' 1739. Ten coloured damask darns of cruciform shape surround the inscribed panel with smaller examples of monochrome linen darns including a corner darn worked in the lower half. The central squares of all but the two top right-hand darns and the mono-chrome darn have had warp and weft cut away so that the darning of the four arms becomes a form of needle weaving in the centre. The palette of colours is similar to those of many eighteenth-century North European samplers, particularly Dutch and North German work. A Dutch or German origin is also suggested by the date in that darning samplers appeared to be reasonably well established in Northern Europe, but did not gain widespread popularity in England or North America until the latter part of the century. The patterns look deceptively simple, but considerable skill was required to produce such painstakingly accurate work. Such skills were invaluable when tackling the repair of personal and household linen and all types of garments and hosiery. Fine work became increasingly important when lighter cotton and muslin gowns dominated fashion in the late eighteenth and early nineteenth cen-turies. Even when heavier dress fabrics returned to fashion, the discipline of darning skills was encouraged and incorporated into the sewing syllabus of schools. Quaker school samplers, both English and North American, tended to be worked in distinctive pattern darns making them as identifiable as the medallion or 'pin-cushion' patterns found on other Quaker samplers (no. 31).

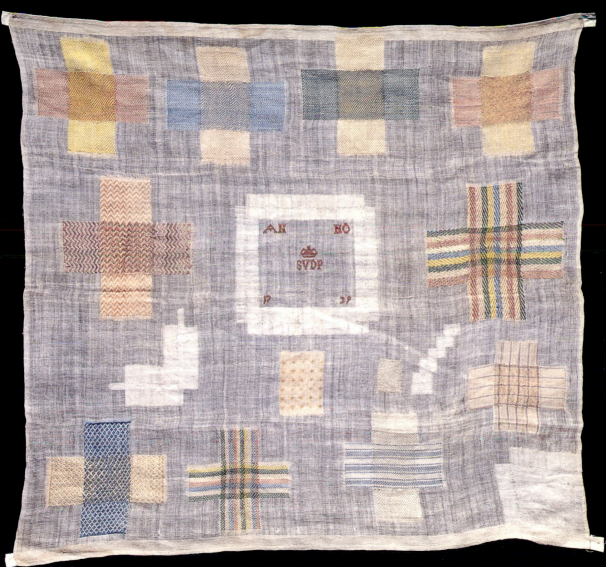

SPOT MOTIF SAMPLER

DUTCH, 1764

*Linen. Embroidered with polychrome silks in
cross stitch. Three edges hemmed, selvedge left side.
50.75 × 49.25 cm. T. 88–1938.*

A considerable number of samplers of this type exist, with their orderly, almost symmetric arrangement of motifs, bland colour range, and almost square shape. They mostly date from the last few decades of the eighteenth century and the early ones of the nineteenth century. The thirty-nine detached motifs are enclosed in a narrow border with a secondary border along the bottom of conventional bird motifs and a selection of buildings, one with a Dutch gable end, the others more fancifully ornate. The largest turreted building is similar to those worked on English samplers of a similar date and often called 'Solomon's Temple'; it carries the date 1764. The mixture of motifs that are common to English and European samplers, for example flower vases, sprigs, birds, mermaids, with those that are more characteristically Dutch is quite usual. Even the figurative motifs follow this pattern. Adam and Eve in the centre and the spies from Canaan at the top are depictions of biblical stories popular across Europe. In contrast other groups of figures appear to be wearing local costume, some even placed with typically Dutch furniture. Windmills often feature on Dutch samplers, but have been omitted in this case although the equally popular sailing-boat is included with flags in the national colours, now faded, of orange, white, and blue, flying from the masts. Three motifs from the top row provide further information on the provenance of the work. The lion rampant symbolises the independence of the United Provinces from Spanish domination, finally achieved in 1648. The armorial bearing of an imperial eagle with an escutcheon on its breast denotes the northern province of Groningen; the escutcheon is probably that of a provincial town. The star within a square surrounded by a stylised wreath or floral border is typical of embroidery from the north of Holland as well as the Friesland Islands and neighbouring German territory. The inscription 'IANNE tIe kRIe kAAR' is the maker's name, 'JANNETIE KRIEKAAR'.

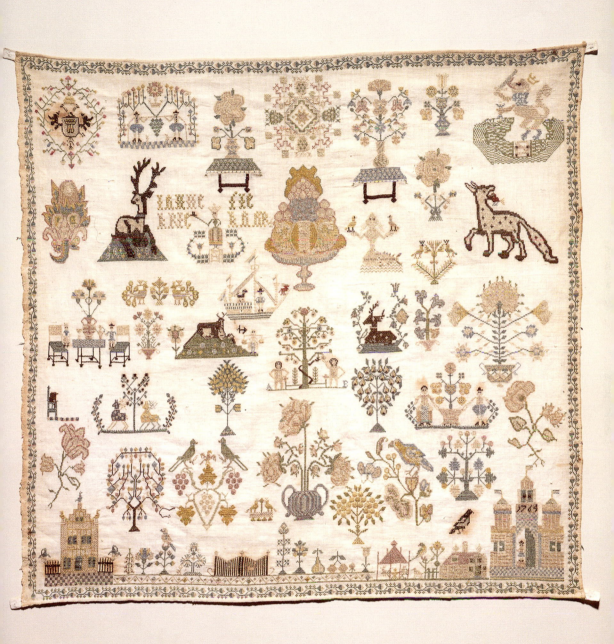

BAND SAMPLER

GERMAN, LAST QUARTER OF THE
EIGHTEENTH CENTURY

*Linen. Embroidered with polychrome silks in cross
stitch with a very few back stitches. All edges hemmed.
26 × 49.75 cm. T. 107–1938.*

The alphabet and numeral bands, as well as the two of stylised floral repeat patterns, are similar to many dated eighteenth-century German samplers. In general those from the earlier part of the century tend to be even longer, but do not include the multitude of pictorial elements that are found on this sampler. Despite lacking the conventional wreath encircling initials or name and date, the sampler is worked with many motifs particularly popular in the latter half of the century. The Instruments of the Passion are arranged around the Crucifixion with the inscription 'Jesus' above. The small detached motifs include flower sprigs and the sun, moon, and stars. Other pictorial elements worked within horizontal bands include a lion, a two-headed eagle, a duck, a Pelican in her Piety, a squirrel, and a parrot – a typical mixture of traditional, religious, and nationalistic motifs. Another such mixed band includes figures either side of a well, flower vases, and baskets, with a monstrance to the left and a perpetual light to the right.

The simplicity of the stitching and conventionality of arrangement and decoration suggest that this is schoolroom work, with discipline and not spontaneity the prime requirement. The religious symbolism is Catholic rather than Protestant, and, as the sampler was bought in Dresden, the capitol of Saxony, and resembles other samplers from this predominantly Catholic region, it seems reasonable to conclude that it is from central or southern Germany.

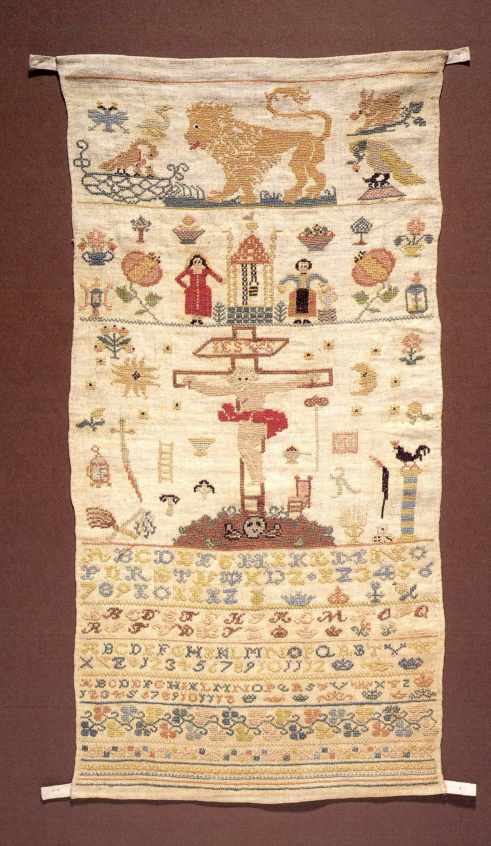

SAMPLER

GERMAN, 1771

*Linen. Embroidered with polychrome silks in
long-armed cross, cross, and satin stitch with a little silver
metal thread, laid and couched. Three edges hemmed,
selvedge at top. 25.7 × 50.5 cm. T. 102–1938.*

This sampler is shorter and lacks the horizontal bands of alphabets, numerals, and small repeat patterns that characterise much eighteenth-century German work. Some attempt is made to arrange the motifs in sections, but above the two lower bands large and small pictorial elements and the inscriptions are randomly placed. Although bought in Nuremberg, the uniformed figure does not appear to be associated with any local militia or organisation. The initials 'S.E.L' and the date '1771' within a wreath was a popular style of inscription in Germany. The pierced or Sacred Heart was also in general use, and the frame of letters surrounding this example could possibly be the initials of friends or family; they do not appear to be a religious monogram. Many of the motifs can be found on samplers across the centuries and national boundaries, for example the floral sprays, the various small animals, the confronting birds. However, some of the other pictorial elements indicate a North German origin rather than the area around Nuremberg. These are the baptismal ceremony, apparently being performed by a Lutheran minister, a crayfish, a traveller in profile, and the chest on a stand with turned legs. There is a North German sampler of 1782 with these motifs, amongst many others, in the Bayerisches National museum, Munich. Proof of origin is always difficult unless the sampler maker includes a place-name in her inscription, but it seems reasonable to assume that this sampler was made by a Protestant girl from the North of Germany.

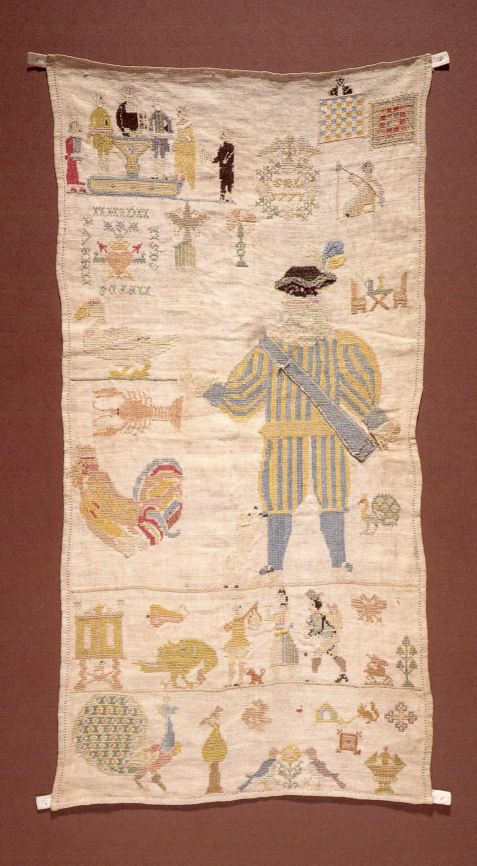

A PAIR OF SAMPLERS

*Linen. Embroidered with polychrome silks in damask and pattern
darning and tent stitch with applied silver metal wire braid. Edges covered
by gathered pink silk ribbon with silver metal wire trimmings.
36 × 31.5 cm (including ribbon). T. 90–1938.*

Although not particularly finely worked, the twenty rectangles of darning are unusually varied in style and colour. As well as the conventional monochrome damask patterns and the multi-coloured stripes, the imitation of more complex woven repeat patterns have been attempted with some success. An inscription has been worked in the centre in a curious mixture of Flemish and Latin 'B.H. den 22 MAI: ANNO: 1760:'.

*Linen. Embroidered with polychrome silks in tent, stem, satin, cross,
and eyelet stitch with silver metal thread. Edges covered by gathered blue
silk ribbon. 38 × 26.5 cm (including ribbon). T. 91–1938.*

The initials 'B H' worked in pink silk, similar to the sampler above, appear twice in each of the floral wreaths held by the two upper figures. The two samplers are obviously a pair. The initials and style of lettering of the inscriptions are identical, and the loosely woven linen ground and ribbon trim similar. There is further inscription within the elaborate floral wreath, groups of initials 'HS / IP / PIN / KSCD' and, almost indecipherable, the date 1760. The wide border contains numerals, coronets, and four alphabets. The five female figures have French inscriptions which suggests that 'BH' came from what is now Northern France and Belgium. More initials are worked in the wreaths of four figures and the column of the fifth. They are all probably those of family or school friends.

The five figures illustrate, with appropriate symbolism, some of the minor virtues closely linked to the aspirations and expectations of an eighteenth-century woman, diligence, constancy, etc. The use of more than one language, the pictorial references to both Christian and classical culture, and the competent execution of various embroidery techniques suggest 'BH' was a well-educated, bilingual young Flemish or French woman.

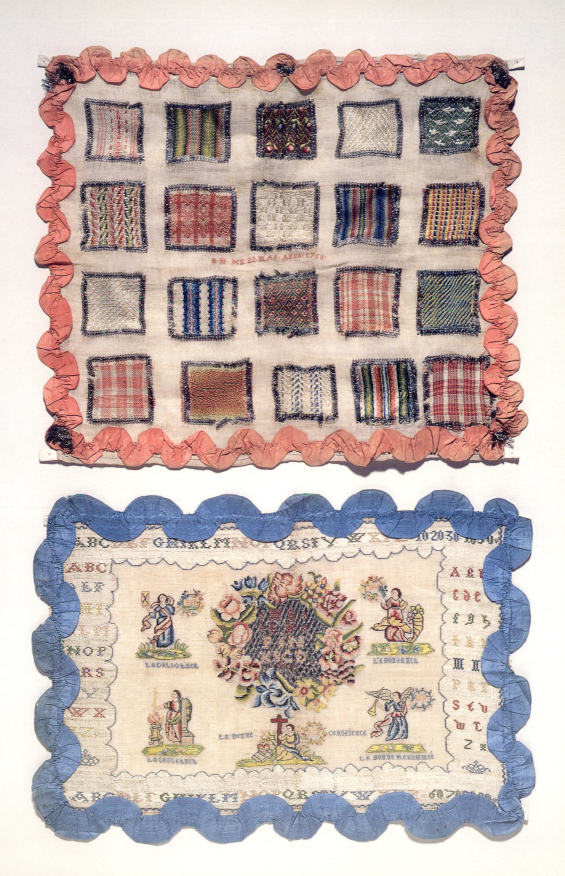

43

BAND SAMPLER

—

Linen. Embroidered with polychrome silks in cross,
long-armed cross, double running, threaded running stitch, and
various over cast drawn thread stitches. Sides hemmed, selvedge
at top, raw edge at bottom. 17 × 68.5 cm. T. 182–1928.

The long, narrow format with bands of repeat border patterns belongs to a tradition of sampler making that stretched from the seventeenth into the eighteenth century. Fortunately the date is indicated by the inscription 'DENOB.ᴱ DE 48/LOA. CABOEN 24 / GELITAFLORES / DEMANO DEAN' which has to be read from the bottom line. It then becomes 'DE MANO DE ANGELITA FLORES LO ACABO EN 24 NOBᴱ DE 48' which translated is 'From the hand of Angelica Flores who finished it on 24 November in 48'. The style of the sampler suggests it was made in 1748 rather than 1848. During the latter half of the eighteenth century, Spanish samplers tended to become more evenly rectangular, large, and flamboyantly stitched as exemplified by that of 1787 (no. 44).

The small, geometric, and stylised floral pattern bands on this sampler are similar to those found on so many European samplers. More distinctively Spanish is the band worked in black silk with the pattern voided or 'in reserve'. This is a technique sometimes found on the earliest, rare sixteenth-century Italian samplers and occasionally on seventeenth-century English samplers. Voided pattern bands are much more numerous on both Spanish samplers and on Mexican and South American work where patterns associated with seventeenth- and eighteenth-century European embroidery, particularly that of Spain, continued in use throughout the nineteenth century. The survival of traditional patterns derived from early pattern books worked in a variey of needle techniques is unsurprisingly encountered in countries where a high standard of embroidery continued to be valued. This was true of Spain, with female education largely provided by religious orders who, in turn, exported their European culture to Spanish-speaking America. Inevitably native American characteristics would then be inserted into such work as can be seen on the Spanish Colonial sampler of 1738 (no. 45).

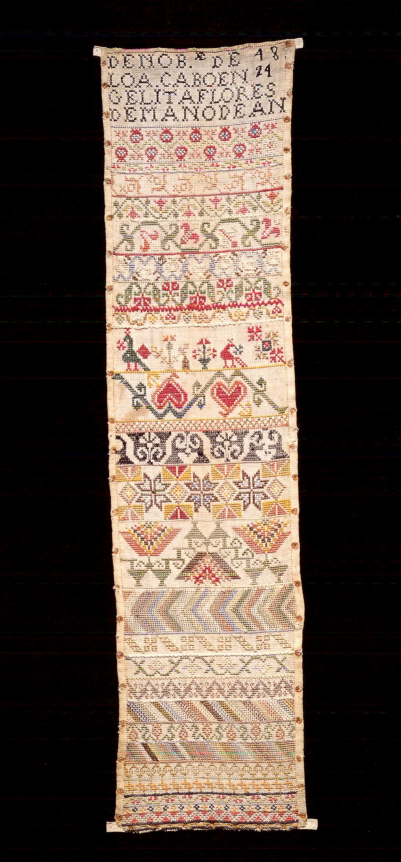

SAMPLER

SPANISH, 1787

◦

Linen. Embroidered with polychrome silks in satin,
double running, four-sided, chevron, and eyelet stitch.
All edges hemmed and trimmed with a fringed red
silk braid or ribbon, silk tassels at each corner.
49.5 × 89 cm. T. 183–1928.

Such spectacular embroidery is typical of eighteenth- and nineteenth-century Spanish samplers. They are often large in size and covered with densely worked bands of patterns in strong colours. Although there are written references to samplers in Spain as far back as the sixteenth century, those that have survived date mainly from the eighteenth or nineteenth centuries. The eighteenth-century examples usually display a high standard of craftsmanship, the earlier ones tending to follow a straightforward arrangement of horizontal bands common to much of Europe. From the middle of the century, the bands are more usually organised around a central panel which is itself framed by a border of inscription. An analysis of the many repeat patterns and the corner motifs show that most are copies or adaptations from the popular pattern books. They tend to look less familiar, because Spanish needlewomen frequently used bright colours for stitches that in other countries were more usually worked in linen thread as part of the repertoire of whitework embroidery.

The inscription on this sampler reads 'DONA MARIA DEL CAR-MENDELOS SANTOS Y DIVISIA AD MDCCLXXXVII', which is the full name, Christian name, and first and second surname, of the young woman who worked the sampler, and the date 1787. Her name suggests that she was probably of noble birth. The armorial bearing within the inscription is almost certainly a version of the arms of the religious order known as the Mercedarians, the Order of Our Lady of Mercy. It is entirely consistent that a girl of good birth would be educated within a convent.

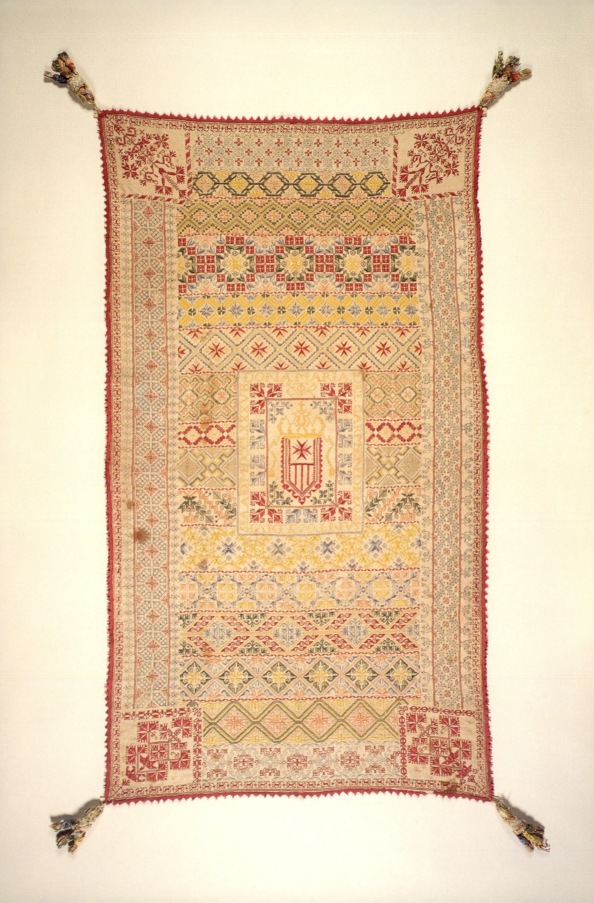

SAMPLER

SPANISH COLONIAL, PROBABLY
GUATEMALAN, 1738

Linen. Embroidered with polychrome silks in buttonhole,
chain, fishbone, satin, and stem stitch, with laid and couched work
and French knots. All edges hemmed and trimmed with pink
and blue silk ribbon, bobbin lace, and incomplete silk
ribbon bows. 38 × 102 cm. T. 121–1938.

The large format and bright silks, as well as the short inscription 'LO HIZO' (made by) 'ANTONIA SANCHEZ ANO DEL 1738' indicate a Spanish provenance. The monogram of Our Lady, the armorial bearing for the Order of Carmelite nuns, and also those of the Inquisition, are typical of convent work. Similar patterns and designs with appropriately worked arms or insignia were embroidered by countless girls educated by religious orders common to Spain and Spanish America. Differentiating between the two is not always easy, although quite distinctive styles gradually evolved in the various countries, perhaps the best example being the Mexican samplers of the nineteenth century with their characteristically naturalistic, flowing floral bands worked in horizontal rows rather than around a central panel. This sampler differs from conventional Spanish work in the use of many figurative motifs, amongst them a large green and red bird, a Quetzel, a national symbol of Guatemala. Its colonial origins are also suggested by the three figures sporting feathered head-dresses, obviously depictions of native Americans. Finally, the particular shade of purple used to work the unicorn does not resemble any of the familiar European natural dyes, and is most likely one obtained from sea shells specific to South America.

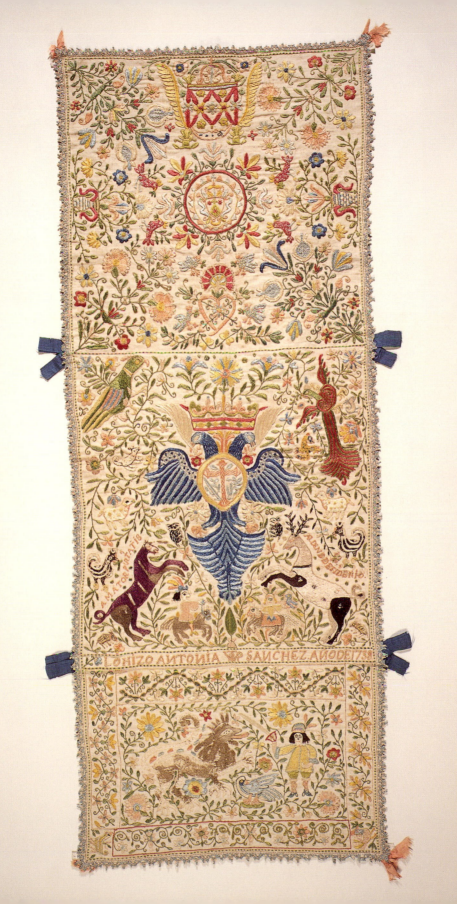

SAMPLER

—

Linen. Embroidered with polychrome silks in double
running, compound double running, eyelet and single
faggot stitch. Two edges hemmed, selvedge at top
and bottom. 85.5 × 44.5 cm. T. 1–1956.

Samplers were not exclusive to Western Europe. They were made in all the countries under Ottoman rule and tended to reflect local embroidery traditions. This example illustrates this trait in that it is covered with motifs and patterns that can be found on Turkish domestic linen and costume. Some of the stitches used are those suitable for double-sided embroidery, which was an essential technique for the two faced towel-ends, kerchiefs, sashes, etc. that were so much used in a Turkish household.

There appear to be two distinct styles of work on the sampler, one of lightly stitched, randomly placed motifs, the other of heavier work depicting naturalistic motifs, corner and band patterns, and a largely indecipherable inscription. Possibly it is the work of two individuals, or alternatively one person may have produced it at different times.

The light, linear motifs include flower vases, sprays, trees, kiosks, a jug, a boat, etc., as well as imported Western European patterns such as the beribboned flower sprays. Amongst the other more densely worked traditional patterns, such as the confronting parrots and the asymmetric flower motifs, various non-Ottoman elements have been incorporated, for example the small-scale, rosebud border repeat patterns and a tree trunk apparently sprouting acorns. Elements of the inscription that can be deciphered include the symbol for Muhammed, and fragments of what appears to be a love poem telling of tears at the thought of separation.

The competent quality of the embroidery suggests an eighteenth-century date, work usually being rather cruder in technique and colour during the nineteenth century.

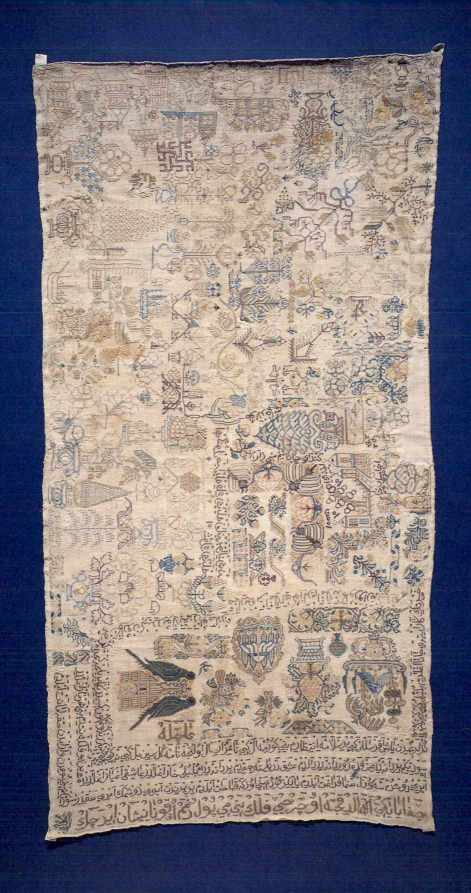

OVAL MAP SAMPLER

—

Silk, with a linen backing. Embroidered
with polychrome silks through both layers in back
and stem stitch with French knots and painted details
on the figures. Raw edges. Max. width 49 cm.,
max. length 52.5 cm. T. 142–1938.

Although there are occasional references to the making of map samplers from the first half of the eighteenth century, they commonly date from the 1770s and continue on into the early decades of the nineteenth century. The combination of geography and embroidery became popular with teachers across Europe, their pupils producing maps ranging from their immediate neighbourhood to country, continent, or the world. In this particular example, the embroidery is elegant and the geographic content reasonably accurate. Quite often the materials and workmanship are shoddy and the geographic knowledge hazy. The different standards reflect the increasing mass production in the nineteenth century of what would now be called 'sampler kits'. It seems likely that the earlier map samplers were drawn or copied by an individual governess or a competent pupil for their personal use. Once the map sampler was seen to be popular then it was commercialised. Hundreds, if not thousands, were printed, on linen or cotton rather than silk, and were often worked in wool rather than silk, frequently entirely in cross stitch. A girl could give her work some small personal touches like the inscription of her name and age. Sometimes she included the name of an obscure town or village amongst the more usual county towns and cathedral cities, which would indicate the whereabouts of her home.

The quality of the work and the use of a satin ground material for this sampler suggest it is one of the more individual works of the eighteenth century. In addition, the dress of the two male figures in the pictorial vignette towards the top of the map appears to be in the style of the 1780s. The naturalistic floral border is also appropriate to work of this date.

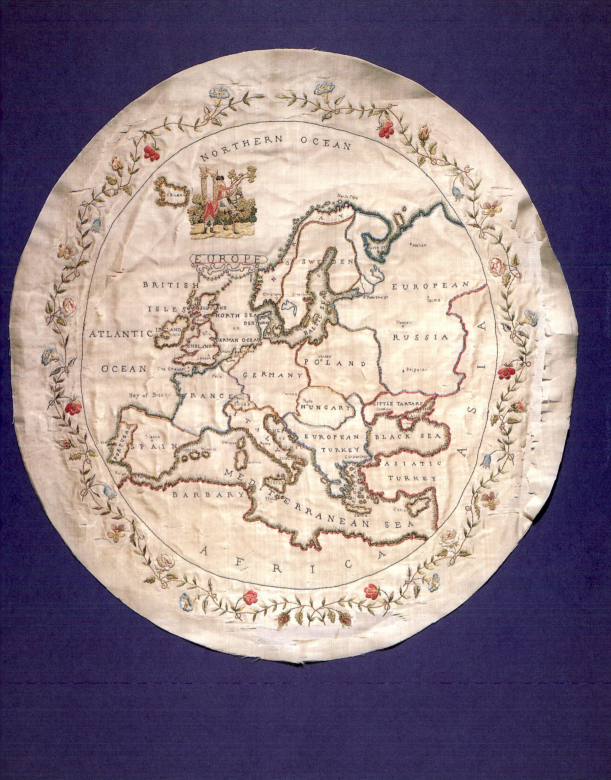

MAP SAMPLER

*Cotton gauze. Embroidered with polychrome
silks in cross stitch. Edged with cotton tape.
77 × 64 cm (including tape). T. 143–1938.*

Similar maps of the Continent with the borders of neighbouring Asia and Africa were embroidered by many girls in many European countries. On the other side of the Atlantic young Americans produced their own map samplers. All were following the popular practice of combining the teaching of embroidery with rudimentary geography. On this example, as well as the national boundaries of the era, major towns, rivers, seas, and mountain ranges are included. The whole is set on a marked grid of the lines of latitude and longitude. A rectangular panel encloses an inscription which, in translation, reads: 'Map / of Europe / presented / to the Count of Fourcroy / State Councillor for life / Director General of Public Education / Member of the Institute etc / 1809.' A very much smaller panel on the lower left of the map is inscribed 'FANNY LE GAY (de Rouen) fecit' – Fanny le Gay (of Rouen) made it.

Fine materials, combined with variations of the scale and the number of the cross stitch lines, have been used to produce a map of Europe that is surprisingly detailed and accurate for an embroidery. The formality of the wording and the high quality of the cotton, silks, and execution of the work suggest this was a presentation piece. A further formal element is the border of alternating branch and palmette motifs linked by scrolls. They are evenly spaced with each corner properly resolved and worked with a diagonal palmette. Although the darning, map, and pictorial samplers so typical of the late eighteenth and early nineteenth centuries often display a high standard of work, particularly those worked on a silk ground, the precision of layout and stitching of this map sampler does suggest that it was possibly the work of a star pupil or could even have been an unusual professional commission.

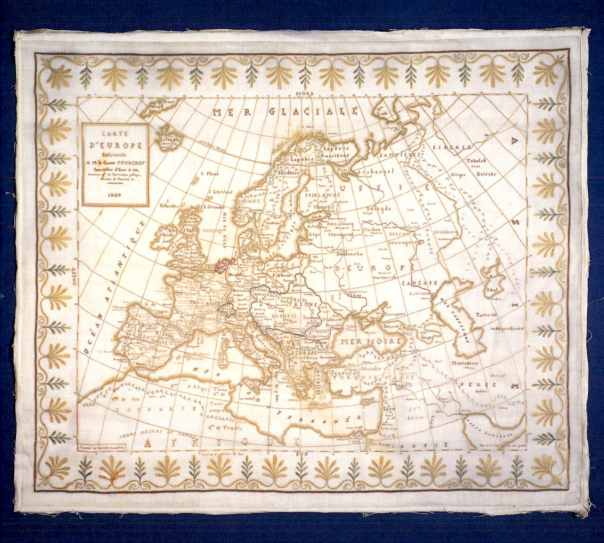

DARNING SAMPLER

FRENCH OR FLEMISH, 1843

Linen. Embroidered with polychrome silks in
pattern darning and cross stitch. Edges glued to board.
49.25 × 46 cm. T. 16–1952.

Darning patterns were worked on European samplers from the early eight-
eenth century and throughout the nineteenth century. The arrangement of
the pattern blocks is sometimes in regular rows as in this example, some-
times arranged around a central inscribed or floral motif as in the earlier
Dutch or German sampler of 1739 (no. 38). It is much less usual to find an
enclosing floral border, particularly one as wide and naturalistic as this one.
All the embroidery is of a uniformly high standard, with twelve precisely
placed damask darns demonstrating a fine needle technique, and the border,
with accurately placed corner motifs, probably worked from a coloured chart
of the type that gave rise to innumerable nineteenth-century embroideries
widely known as Berlin woolwork. The novel idea, which launched the flood
of such embroideries across Europe, was the production of coloured designs
printed on squared paper, each square to be slavishly copied in tent or cross
stitch in the designated shade. A Mrs Wittich of Berlin was the originator of
the idea, and by the 1840s many thousands of designs had beeen sold and
worked across Europe and America. Not only does the border of this sampler
reflect the accurate, if impersonal, style of coloured chart embroidery, but it is
also a characteristic attempt to show the flowers in a three-dimensional, nat-
uralistic manner, which is a concept rarely found on earlier pictorial sam-
plers. Although the style of the embroidery is ubiquitous, the inscription 'P.
DE BAETS CHEZ M. CLAVAREAU 1843' combines a Flemish and French
name, suggesting it was made somewhere in what is now northern France
and Belgium.

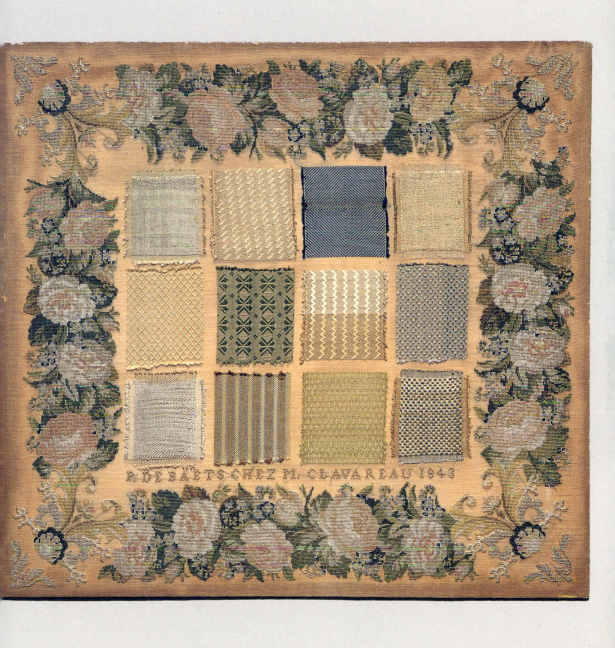

COMMEMORATIVE
SAMPLER

ENGLISH, 1802

*Wool. Embroidered with polychrome
silks in cross stitch with a small quantity of silver
metal thread. Edges bound with dark red ribbon.
31.5 × 39.5 cm (including ribbon).
T. 52–1938.*

Copious inscription with perhaps one or two minor pictorial elements, all within a simple floral border, is one of the typical arrangements of late eighteenth- and early nineteenth-century samplers. Often the inscription is of the Commandments, a Creed, or the Lord's Prayer. Sometimes the purpose is not religious instruction, but commemoration. Perhaps the best-known group are those worked as mourning samplers; it is less usual to see comment on an historic or political event. Mary Minshull did record an earthquake in the City of London on her sampler of 1692, and a year later Martha Wright noted the landing of the Prince of Orange in 1688, his subsequent crowning as king in 1689, and the attempted French invasion of 1692. It was much later, with the death of Princess Charlotte in 1817, that the commemorative mourning sampler became a popular embroidery exercise.

This sampler has been worked to celebrate the Treaty of Amiens in 1802 with a verse full of patriotic fervour. Interestingly the name of the maker, Mary Ann Crouzet, is hardly typically English, giving rise to speculation that she was of mixed French and English parentage. Perhaps the sentiments expressed about the cruelty of war and the blessings of peace are particularly heartfelt. The crossed swords and shield bearing the crosses of St George and St Patrick reflect the nationalistic subject-matter of the verse. The floral border, bands and baskets, trees, branches, and cornucopias are entirely conventional in arrangement and execution.

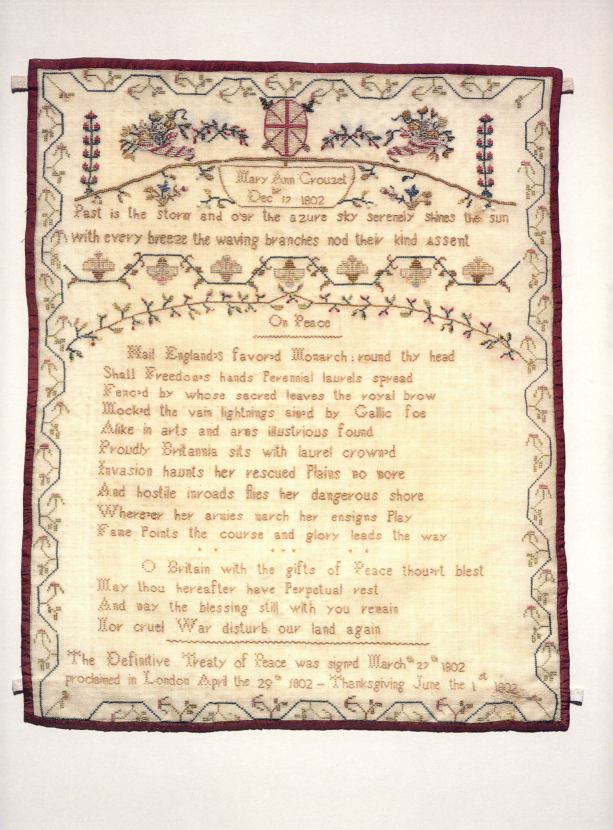

SAMPLER

◆

*Cotton. Embroidered with polychrome silks
in cross stitch. Bound to a paper backing by pink
satin ribbon. 31.5 × 35 cm (including ribbon).
T. 60–1938.*

Fine cotton, such as muslin, tiffany, or gauze, gained some popularity as a ground material for samplers towards the end of the eighteenth century and in the early decades of the nineteenth. Perhaps the female fashion of this period for diaphanous robes encouraged the use of similarly light-weight materials for embroidery. Nevertheless more robust cotton and linen continued to predominate, and such minute stitching on such a delicate ground is unusual. Despite the quality of the work, the conventional motifs and their symmetrical arrangement is entirely typical of early nineteenth-century samplers. More surprising is that such a *tour de force* of stitching does not include the name and age of the embroiderer, particularly as the sampler is almost certainly the work of a talented individual rather than the product of the schoolroom. From the 1820s onwards, needlework had become an increasingly regulated part of a girl's school curriculum. Not only samplers, but a whole series of sewing exercises formed an important part of female education. Inevitably inexpensive materials and an emphasis on plain rather than decorative needle techniques were the norm. Some religious and philanthropic foundations, for example the Quaker schools and the Bristol Orphanage, did establish reputations for quality work, although quite unlike this anonymous sampler. The combination of fine materials with a stereotyped arrangement of motifs suggest it was worked by a young woman in the early part of the nineteenth century.

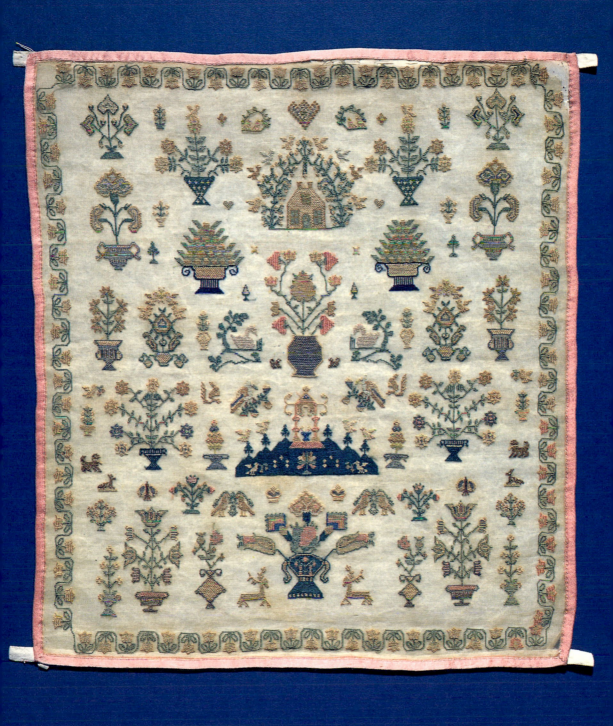

FORGED SAMPLER

ENGLISH, NINETEENTH CENTURY.
DATED 1672

●

*Wool. Embroidered with polychrome silks in cross,
four-sided, tent, stem, and satin stitch. Top and bottom
hemmed, selvedge each side. Small patch behind
lower-left tree, embroidered to match original.
32 × 29.5 cm. T. 69–1938.*

It is difficult to imagine what motive L. Hart had when she stitched the date 1672 onto her sampler. The practice of unpicking part of an inscribed date in order that the real age of the maker was not revealed in later years was not uncommon in the nineteenth century, but such discretion was not the reason for naïvely predating a sampler by some three hundred years. Obviously the maker was aware of some of the characteristics of seventeenth-century samplers, and included her version of horizontally worked alphabet and floral repeat-pattern bands. However, there are many discrepancies between a true early sampler and a nineteenth-century interpretation: a woollen rather than a linen cloth has been used, an almost square shape has replaced the typical long and narrow format, a border has been worked on all four sides and the small detached motifs, although based on traditional patterns, are worked in the rather more naturalistic style of the eighteenth and nineteenth centuries. Finally, the inscribed tune and verse are conclusive proof of a nineteenth-century date. The tune was composed by Alexander Robert Reinagle (1799–1877) and was first published in 1830. It is called 'St. Peter's' because at that time Reinagle was organist at St. Peter's-in-the-East, Oxford. In addition to this sampler, an A. Hart, presumably sister to L. Hart, worked a slightly smaller, very much less complex and more coarsely stitched sampler, which bears no resemblance to seventeenth-century work. She mysteriously dated it 1695.

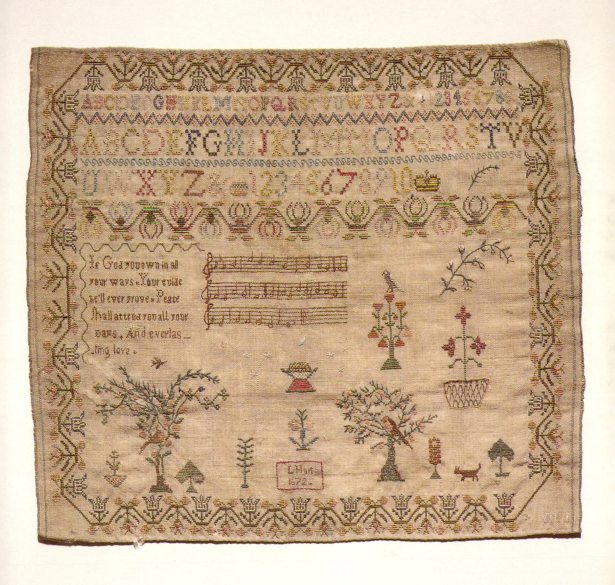

BAND SAMPLER

GERMAN, 1829

—

*Linen. Embroidered with polychrome silks in cross
stitch. Top and bottom finished with decorative button-
hole stitch, sides pink selvedge. 27 × 79.25 cm.
T. 180–1928.*

The tradition of long, narrow samplers decorated with alphabets, numerals, and repeat border patterns continued across German-speaking Europe into the first decades of the nineteenth century. However most of the later examples nearly always included, in addition, a section devoted to pictorial motifs. On this sampler the floral, animal, and bird motifs, and figurative, pastoral, and architectural scenes are worked in a naturalistic style, intricately shaded and detailed to give a three-dimensional aspect. They were probably copied stitch by stitch from the coloured charts first published in Berlin at the beginning of the century and soon popularised by a print seller called Wittich. This most ubiquitous of nineteenth-century embroidery is commonly called Berlin woolwork. Originally the canvases were worked in high quality worsted wools, but soon the multiplicity of coloured charts were copied in coloured cottons, silks, and even beads. As on the sampler, cross stitch was the dominant, although not always the exclusive, stitch, tent, double cross, and plush stitch being quite usual additions. Of the seven alphabets which are worked here, the largest is stitched in a multi-coloured style which is usually associated with embroidery of the Biedermeier period, the 1820s to 1840s. A very similar alphabet occurs on a sampler from Silesia dated 1833 and now in the Museum für Völkerkunde, Berlin. The Silesian sampler also has a virtually identical floral wreath with rake and watering can. Such was the popularity of the mass-produced, coloured embroidery charts that it is quite common to find such similarly worked motifs on samplers and domestic embroidery across much of Europe, particularly the German-speaking areas of Central Europe. The inscription on this sampler is simply 'Fanny Schenkelberg 1829'. Quite often German samplers include the name of a school or teachers; possibly the initials 'W' and 'A' enclosed in floral wreaths were those of Fanny's school-teacher.

BERLIN WOOLWORK SAMPLER

ENGLISH, MID NINETEENTH CENTURY

—

Cotton, double canvas. Embroidered with polychrome wools
and silks in cross stitch with a little long-armed cross stitch. Edges
bound with green silk ribbon. 52 × 59.5 cm. T. 35–1984.

The twenty-nine detached motifs are of predominantly geometric designs, with some including stylised flower and foliage patterns. There is also a group of four leaf and bud motifs. Some textural variety is given to the simple stitching by highlighting a selection of the patterns with thick, lightly twisted silk. Similar bold, brightly coloured motifs were also worked on samplers made of a very long, narrow strip of canvas, often ribbon bound, which could be rolled up neatly over a padded cylinder or wooden roller. Whether long and rolled or rectangular, the samplers sometimes included other popular nineteenth-century stitches, particularly Florentine and plush or velvet stitch. Beads and metal threads were also occasionally incorporated into motifs, which were not always the rather stark designs illustrated here, but were quite frequently of a rather more naturalistic, shaded style. There was also a considerable variation of ground materials in use in the mid nineteenth century, from plain, single thread, linen canvases, to German cotton canvases with every tenth thread coloured yellow, and Penelope or double canvas, an American invention of the 1830s. Double canvas facilitated the use of two different scales of stitching.

The coloured blocks found on this type of sampler were based on printed coloured charts, which were first produced commercially by the Wittichs in Berlin at the beginning of the nineteenth century. By 1840 vast quantities of cross stitch embroidery were worked according to a chart. Their immense popularity was based on the ease with which they could be bought, and the simplicity of merely copying a design when each coloured square represented a simple stitch in a specific colour. It is thought that these uninscribed, non-pictorial samplers were made either for use as teaching aids, or possibly as examples of patterns and colour ways, by women seeking embroidery commissions. If either contention is true, then the Berlin woolwork sampler fulfilled the original purpose of a sampler as an *aide-mémoire* which could be referred to during a lifetime of work.

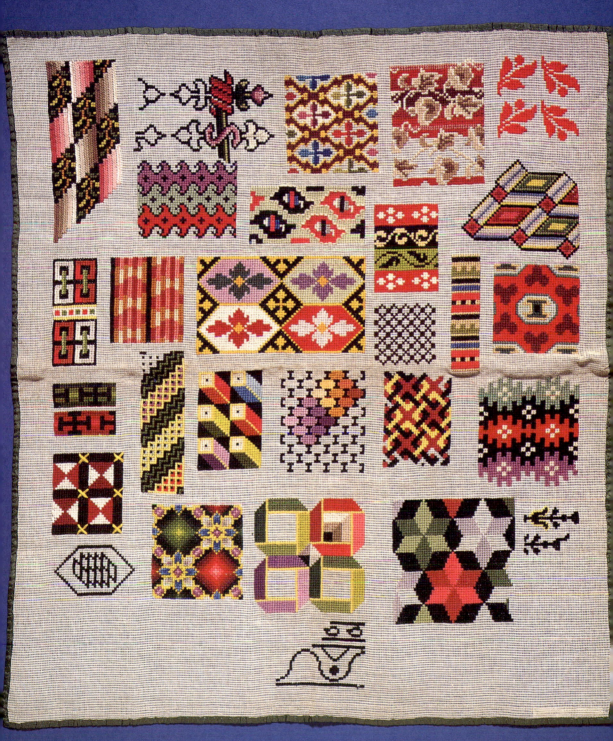

BEADWORK SAMPLER

FRENCH, NINETEENTH CENTURY

*Linen canvas with a cotton patch, mounted on
board. Worked with coloured beads with some later
woollen cross stitch. Edges bound with silver braid.
25.25 × 33.25 cm. T. 20–1940.*

Beads have frequently been incorporated into embroideries, as well as being used exclusively in, for example, seventeenth-century English beadwork pictures or for small bags and purses made in many parts of Europe, with particularly fine work being produced in the latter half of the eighteenth century. During the nineteenth century these two traditions continued, and beads were used in conjunction with Berlin woolwork charts for either highlighted detail or as a complete alternative to wool or silk thread. Despite the long history of beadwork embroidery, samplers in the technique are surprisingly rare and are more usually worked in conventional materials with beads used for details or inscriptions. This unfinished example was obviously intended to be worked entirely in beads. It is almost certainly French, being inscribed 'amitie' and including religious motifs such as the Crucifixion, the Instruments of the Passion, and the Lamb of God, all indicating a Catholic provenance. The flower baskets and a version of the Temple of Solomon are traditional sampler motifs and can be found on samplers from Europe and North America. Unfortunately only one Gothic initial has survived, with darns indicating where two others were worked. Where the bead background is unfinished, an odd patch has been inserted and some crude woollen cross stitch worked close to the narrow beadwork edge.

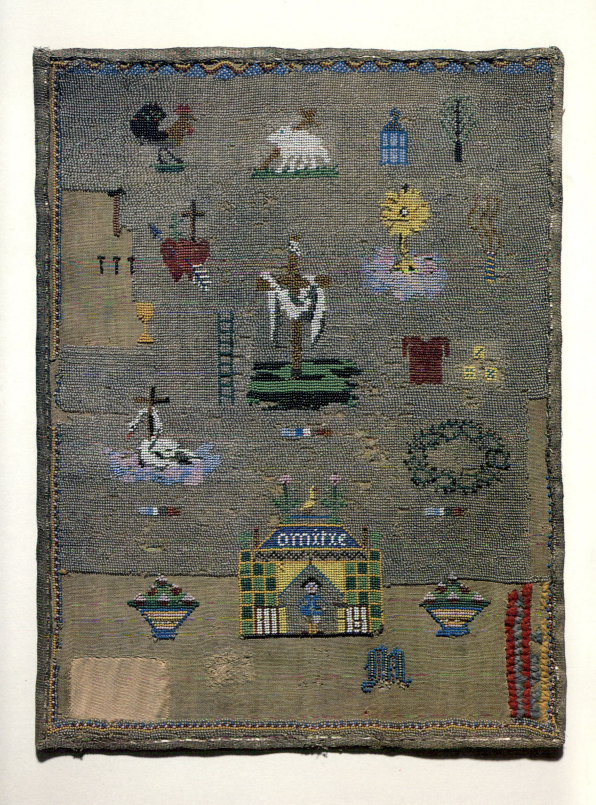

TWO SAMPLERS

Linen. Embroidered with polychrome silks in cross stitch.
All edges hemmed, 51 × 28.25 cm. T. 118–1938.

Although many of the motifs used are common on European samplers – sprigs, baskets, birds, a cupid, Solomon's Temple, etc. – others, particularly the figures, appear to be illustrating Portuguese daily life. They include women in contemporary costume, one of whom is black and carries a flower basket on her head. The implication is that she was a servant, a rare but not unique depiction. As early as 1761 the sampler by Elizabeth Philips of Devon included both family and servants, two of the latter being black. There are also nineteenth-century samplers from the southern states of the USA with black figures. Particularly interesting are those of c. 1865 with inscriptions such as 'We come from Carolina and we are all free now', celebrating the abolition of slavery. The pastoral scene in the top left corner is worked in a contrasting, naturalistic style, probably copied from a coloured chart. The incomplete border of various repeat patterns gives some spontaneity to the work, suggesting a personal rather than a schoolroom exercise. Only the maker's initials 'M:IC' are inscribed beneath a coronet over pierced hearts and birds on a branch.

Linen. Embroidered with polychrome silks in cross stitch.
All edges hemmed. 60 × 30 cm. T. 117–1938.

Although the quality of the work seems more consistent than that of the previous example, this sampler also combines stylised, geometric motifs and patterns with the splendid, naturalistically worked cockerel. Possibly copied from a coloured chart, textural interest is provided by a judicious mixing of cross stitch over single and double threads, most effectively on the tail. The accurate stitching, complex corner motifs and the subtle shading of the fowl are of a high standard and may well be the work of an older girl aiming to be a teacher or a professional needlewoman. The only inscription is the initials within a large central lozenge.

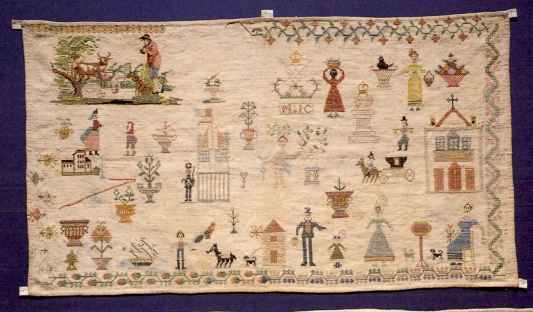

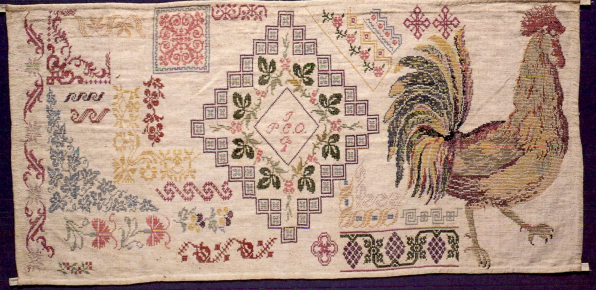

SAMPLERS FROM A SCHOOL BOOK

ENGLISH, WORTHING,

1835

A twelve-leaf book containing plain sewing and stitching
samplers and two miniature nightshirts. The two pages illustrated
show a cotton sampler worked with red cotton in cross stitch and three
coarse linen samplers worked with blue cotton in darning stitch.
Page size 22.5 × 27.25 cm. Cotton sampler 10.75 × 15 cm.
Middle darning sampler 10.25 × 7.75 cm.
T. 147–1938.

Many school books of needlework exercises have survived from the nineteenth century. Typically they include a variety of small samplers demonstrating plain sewing and embroidery techniques. There are also diminutive items of clothing showing dressmaking skills and occasionally examples of knitting. The stitched leaves bound by board covers provided protection for work that may only have been kept as a memento of schooldays but was frequently used as a reference or instruction manual for a girl's future employment.

Throughout the nineteenth century books of sewing instruction were published for use by teachers and pupils. All were similar in content, and the work they generated was stereotyped and conventional, their purpose being the production of competent rather than creative needlework. The two pages illustrated certainly show that Emma Hart of Worthing School was capable of fine cross stitch and accurate darning. The remainder of the exercises include four other lettering samplers, two of red cotton on cotton, and two of pink wool on scrim; three pages of plain sewing which include panels of fine gathering and two rows of buttonholes; two pages of nightshirts displaying essential dressmaking techniques. The final two pages hold three darning samplers, the largest of which has four corner darns and the inscription 'Emma Hart./Dec.11.1835'. Possibly the book was the work prescribed for 1835 with the December sampler being the final product.

It is worth remembering that it was not until the 1860s that the sewing machine began to remove some of the drudgery associated with the sewing and repair of all soft furnishings, household and personal linen, and costume. The skills learnt by Emma Hart in her book of samplers were essential for most women of her era.

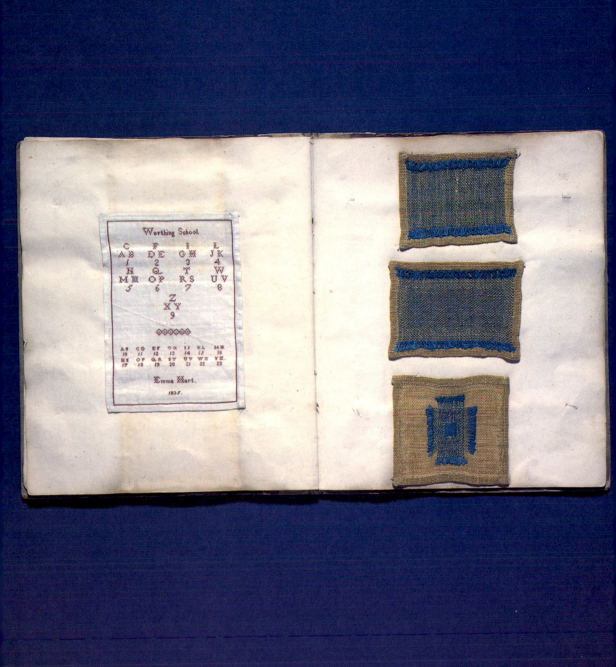

Worthing School.

C F I L
A B D E G H J K
 1 2 3 4
 N Q T W
M O P R S U V
5 6 7 8
 Z
 X Y
 9

AB CD EF GH IJ KL MN
10 11 12 13 14 15 16
EH OP QR ST UV WX YZ
17 18 19 20 21 22 23

Emma Hart.

1835.

MARKING SAMPLER

ENGLISH, 1868
(THE TAIL OF THE 6 IS MISSING)

*Cotton. Embroidered with red cotton in
cross and four-sided stitch. All edges hemmed.
29 × 37.5 cm. T. 11–1952.*

No space was wasted on this typically densely worked Bristol Orphanage sampler, a contrast to most ordinary school samplers which were simple in design and inscription. Although worked by orphan children, the Bristol samplers have an almost professional, business-like appearance, unsurprising in that they fulfilled the purpose of a CV or reference for a girl seeking a job in service.

The first Bristol Orphanage was opened in 1836 by George Müller, a minister of German extraction, and by 1870 there were five such foundations. Although religious instruction played a large part in the disciplined life of the orphans, Müller, rather ahead of his time, recognised the importance of giving children an education and a trade. An obvious choice for the girls was to start their life of employment as housemaids or laundry maids. The compilation of alphabets, numerals, and small-scale border patterns on this sampler provided an *aide-mémoire* for a girl responsible for a family's linen. Her sampler was essentially useful and only coincidentally decorative. It is its function as an example of lettering and pattern to be referred to throughout a working life that links it to the earliest-known samplers made for a similar purpose. It is the social position of the young women that is so very different, the rich and leisured women of the past contrasted to the employed servant girl of the nineteenth century.

In addition to the rows of alphabets, numerals, and patterns, there is an inscription of an extremely popular, morally uplifting verse, above which is a Bible and a row of paired initials. 'M. A. Tipper / Orphan House / North Wing / Ashley Down / Bristol / 1868' is worked at the bottom. Some of the other orphanage samplers have three-figure numbers rather than the paired initials; both identify pupils.

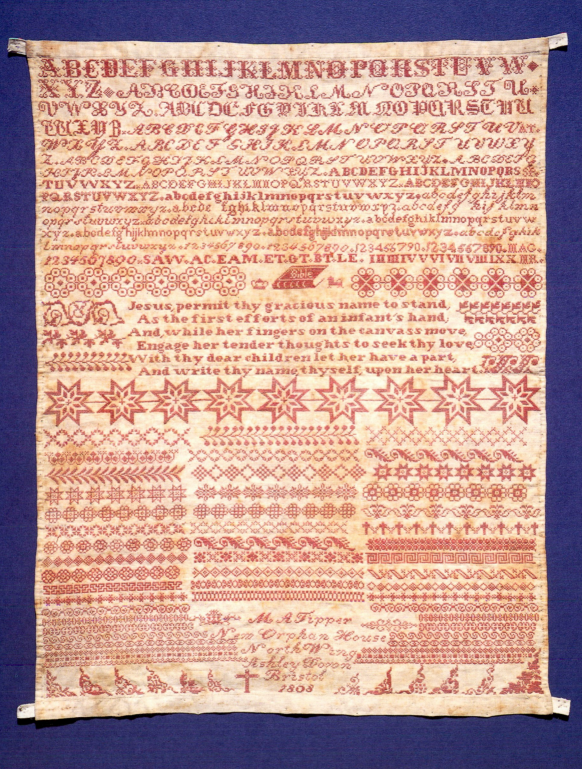

SCHOOL SAMPLER

GERMAN, 1879

*Cotton. Embroidered with white, red, and black
cotton with a small amount of silver metal thread in satin,
stem, running, and eyelet stitch. Edges trimmed with narrow
bobbin lace. 41 × 33 cm (excluding lace). T. 112–1938.*

Although this sampler was bought in Dresden in the early twentieth century, it is not worked in the technique associated with this city, namely whitework emulating bobbin lace. However the delicate floral sprays with other small figurative and decorative motifs worked in dense, minute satin stitch with punched or drawn eyelet holes is typical of German-speaking Central Europe. Often the embroidery was exclusively white, but sometimes, as on this sampler, it was accompanied by one or possibly two strong colours. The combination of motifs, stitching techniques, and limited colour range was popular throughout southern Germany, and extended into Switzerland and Czech Bohemia. Its use on dowry textiles continued well into the twentieth century in these areas.

This sampler includes typical detached motifs, four alphabets, one of which is in Gothic script, numerals, and the name of the maker, Antonie Rünger, in very elaborate lettering. In addition, there is an armorial bearing, the name of the school 'Bezirkschule' and an inscription which, in translation, reads 'A memento of my schooldays'. Scattered amongst motifs and inscriptions are the name or initials of teachers and pupils, with the date of completion at the bottom. The high quality of the work and the sentiments embroidered suggest that this was a young woman's final sampler, the product of an education which had included expert instruction in various forms of needlework.

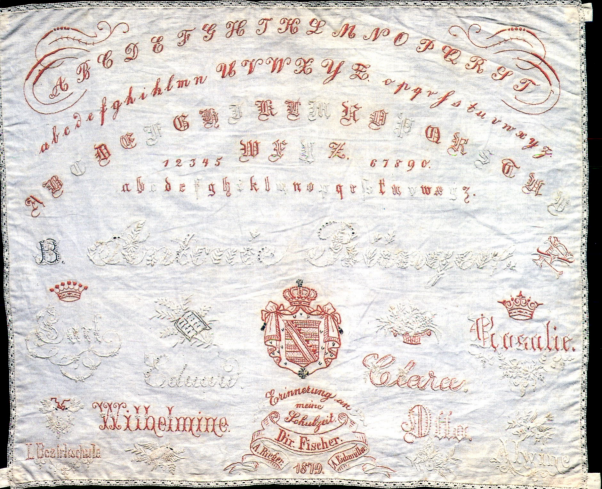

WHITEWORK SAMPLER

GERMAN OR DANISH,
1853

*

*Cotton. Embroidered with white cotton in chain
stitch with panels of pulled work. All edges hemmed.
12 × 30.25 cm. T. 4–1939.*

The continuing popularity of fine whitework embroidery for use on costume accessories, infants' clothing (particularly Christening robes), and household and personal linen is demonstrated by the quality of this mid nineteenth-century sampler. The various techniques of whitework are often associated with particular places and particular times, for example hollie point with eighteenth-century England (no. 32). Fine drawn work, often called Dresden embroidery, enjoyed great popularity in Europe and North America in the mid eighteenth century at a time when it was a less costly alternative to the hugely expensive bobbin laces. Towards the end of the eighteenth century and in the early nineteenth, the simplicity of female fashion witnessed a decline in the use of lace and associated whitework embroidery for fashion accessories. Simpler whitework techniques, such as chain and satin stitch, continued to be used to decorate the light cottons and muslins of fashionable dress. But, with the return of more elaborate styles in the 1830s, the more complex whitework techniques enjoyed a revival and were again in demand for their traditional purposes. This mid nineteenth-century sampler is proof that the techniques survived despite the vagaries of fashion, and it was not until later in the century that hand work succumbed to the challenge of cheap, mass-produced machine-made embroidery and lace. The quality of the work done by the young woman known only by her initials 'F. J. R. Z.' is not only typical of that produced in such areas as Germany and Denmark, but it also makes an interesting comparison to some of the finest seventeenth-century whitework samplers. The needlewomen display similar levels of expertise, even if the style of work is separated by decades of changing taste.

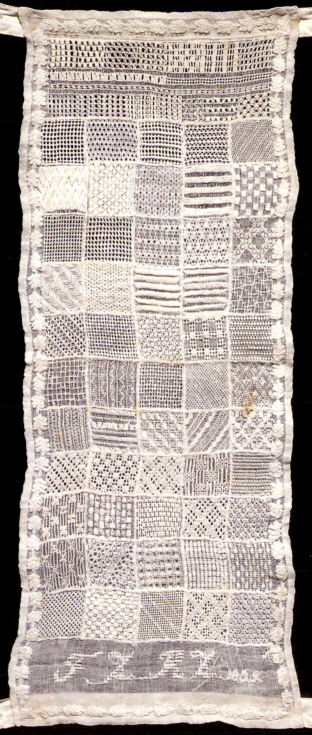

TWO ITALIAN SAMPLERS

ITALIAN, 1824

*Linen. Embroidered with polychrome silks in cross stitch.
All edges hemmed. 43.5 × 28.5 cm. T. 10–1949.*

The pale colours, the random arrangement of motifs and the horizontal format are a favoured combination on many Italian samplers of the late eighteenth and early decades of the nineteenth century. Similar characteristics can also be found on examples from northern Europe, Germany, and Portugal. Apart from the monogram of Christ and what appears to be a monstrance on the lower centre of the sampler, most of the rest of the motifs and the repeat patterns are secular, stylised, and in the European tradition. Slightly less stereotyped is a rose spray, which is more realistically shaded, and a border pattern with a flower garland draped along a pole. A small, neat, border pattern worked in four different colours encloses the whole, which also includes an alphabet and the inscription 'LUIGIA C ENZOLI LAN NO 1824'. Lacking any variation in stitch or individually in design, the sampler was probably a schoolroom exercise.

ITALIAN, 1912

*Linen. Embroidered with polychrome cottons in cross, double hem, back or
double running stitch. Edges finished with double hem stitch; each corner trimmed
with three swatches of knotted cottons. 33.25 × 27.5 cm. T. 115–1938.*

This sampler, although less emphatically horizontal in form and with some variation of stitches, continues an Italian style of sampler-making that extends as far back as the late eighteenth century. In some respects it is similar to the work of 1824. It includes detached motifs and patterns and a simple inscription of name, place, and date, 'GIORNI LIETI ASSISI APRILE 1912'. The dominant feature is the alphabet, rather more decorative than that on routine school samplers. When it was brought by Mrs Longman, she noted that it had been made by the Italian equivalent of the Ladies Work Society, i.e., women of gentle birth in reduced circumstances attempting to earn a living with their needles. Despite coming from Assisi, it carries no example of the embroidery called Assisi work, a voided technique where the background is filled with cross stitch with the design left unworked.

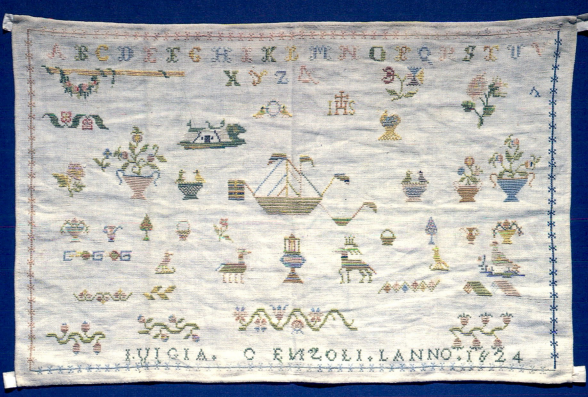

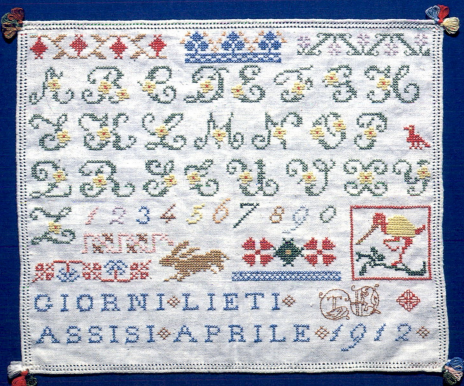

PLAIN SEWING SAMPLER

ENGLISH, 1896

—

Flannel. Worked with light green silk to show
dressmaking, mending, and some simple embroidery
techniques. Edges hemmed, buttonholed or bound with
cream silk ribbon; cotton band along top right edge.
39 cm. (max.) × 26.5 cm. (max.).
T. 8–1991.

This strangely shaped sampler was a format quite widely adopted in the late nineteenth and early twentieth centuries because it allowed a young needle-woman to demonstrate her ability to perform a variety of dressmaking, plain sewing, and decorative techniques. A gusset, pocket, tucks, pleats, patches, darns, buttonholes and hand-made buttons were usually included. Minutely hand-stitched seams and hems were often decorated with simple embroidery stitches. The ground material could be flannel, cotton, or linen. Needlework continued to be an important part of a girl's school curriculum through the nineteenth century and into the twentieth. Young women, who were either training as pupil teachers or were at a Domestic Science College, would be expected to produce work of this standard, and, in turn, to instruct the young to a high level of competence. Most samplers of this type are dated, the greatest number falling into the years 1890–1920. They are usually initialled by their maker, in this case 'E A F', and this one is also inscribed '4th Yr. 1896'. It is known that the maker was a teacher and that she was called Ethel French, but it is not known whether she trained at college or as a pupil teacher. Her sister, Amy French, made a similarly shaped sampler of white cotton, worked in white cotton thread and dated 1900. It was not until well into the twentieth century that the domestic sewing machine was firmly established with the consequent decline of hand sewing. From the 1920s the making of school and institutional samplers was almost completely abandoned.

PICTORIAL SAMPLER

ENGLISH, 1926

—

Linen. Embroidered with polychrome silks in tent, cross,
and darning stitch with gold metal thread laid and couched.
Mounted on a board, edge turned onto the reverse and bound
with tape. 44.75 × 53 cm. (front of board).
T. 6–1982.

It is known that this sampler was worked whilst the maker was at college, and was an original design. Without this information and the tiny inscription 1926 'C.M. Thompson age 17' it could easily be assumed that the embroidery was purely decorative with none of the more utilitarian aspects of a sampler. But when stitch and motif are analysed, it becomes obvious that many of the sampler traditions of the past have been adapted to the fashions of the 1920s. Embroidery completely covering the ground material was popular through-out this decade, and is well illustrated by this sampler. Rows of darning stitch, spaced alternately and worked on the counted thread with total accuracy in shaded silk form the background. The pictorial elements are in fine tent stitch and the variously shaped geometric panels are outlined in double rows of cross stitch within a laid and couched metal thread border. Although 'twenties' in style, the symbolic portrayal of the four seasons in the fine and decorative arts had been popular from late antiquity onwards. On the sam-pler, Spring, Summer, and Autumn are a contemporary interpretation of the sentiments expressed in the verse, whereas Winter is depicted traditionally as a thickly clad figure. In similar vein the floral sprigs and insects filling the var-iously shaped small panels may be twentieth century in style, but they have their roots in the motifs found on 'spot' samplers and pictorial embroidery of the seventeenth century. Although the variety of stitches used is more limited than that of early samplers, the quality of the materials and the technical com-petence of the work is a continuation of a standard that had largely been lost when samplers increasingly became a simple schoolroom task.

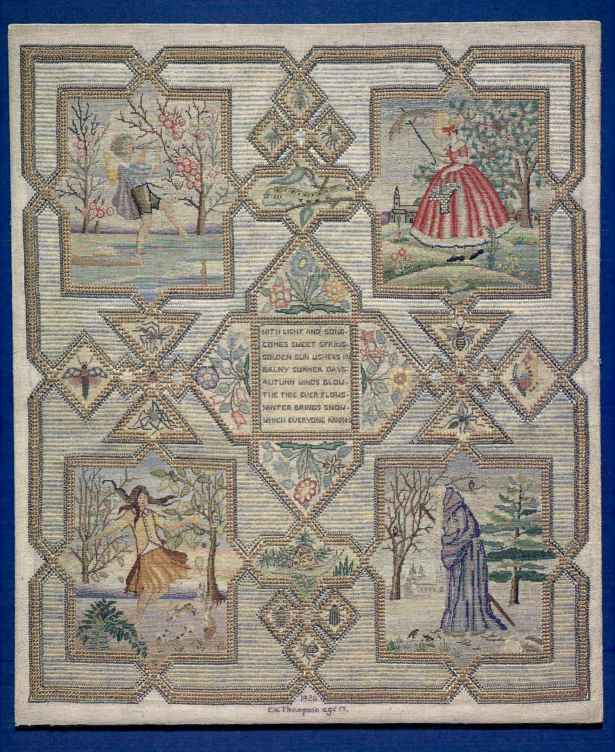

WITH LIGHT AND SONG
COMES SWEET SPRING
GOLDEN SUN USHERS IN
BALMY SUMMER DAYS
AUTUMN WINDS BLOW
THE TIDE EVER FLOWS
WINTER BRINGS SNOW
WHICH EVERYONE KNOWS

1926
E.M. Thompson age 13.

CITY AND GUILDS SAMPLER

ENGLISH, 1931–1933

—

Linen. Embroidered with polychrome cottons in satin,
buttonhole, chain, fishbone, daisy, stem, running, and whipped
running stitch with buttonhole wheels, laid and couched work,
French knots, and needle weaving. All edge hemmed.
21 × 42 cm. T. 1–1983.

This is the first of three samplers bound together at the top with buttonhole bars which were worked for the Part I Examination of the City and Guilds of London Institute. A variety of embroidery stitches and techniques are demonstrated in horizontal bands with one rectangular panel of freestyle embroidery. The second sampler, of smaller size and slightly coarser linen, includes pulled work and Assisi work, and the third Richelieu work and Broderie Anglaise. Both include other decorative stitching, and where the design is freestyle traces of red and grey pencil drawing are visible.

Although samplers of an elementary standard continued to be made in schools into the early twentieth century, they provided little in the way of proper stitching instruction. This purpose was only really continued in adult institutions or in apprenticeship schemes which prepared women for careers as teachers or professional needlewomen. Those women who were unable to attend as full-time students could seek qualifications through the examinations of the City and Guilds Institute. The working of a book or set of samplers such as these provided not only the necessary proof of the ability of the examinee, but also a portable reference of stitch and design and an example of work for the next generation of pupils. In these respects this twentieth-century work was similar in intention to the earliest samplers which were a means of both recording and handing on the skills of embroidery, whether in a domestic or institutional environment.

FURTHER READING

Arthur, Liz, *Embroidery 1600–1700 at the Burrell Collection*, John Murray in association with Glasgow Museums, 1995.

Ashton, L., *Samplers*, The Medici Society, London 1926.

Bolton, E. S. and Coe, E. J., *American Samplers*, Dover, New York 1973.

Carmignani, M., *Imparaticci-Samplers*, Florence 1986.

Christie, G., *Samplers and Stitches*, Batsford, London 1920.

Clabburn, P., *Samplers*, Shire Publications Album 30.

 The Needleworker's Dictionary, Macmillan, London 1976.

Colby, A., *Samplers Yesterday and Today*, Batsford, London 1964.

Edmonds, M. J., *Samplers and Sampler Makers. An American Schoolgirl Art. 1700–1850*, Charles Letts, Los Angeles and London 1991.

Ewles, R., *One Man's Samplers, The Goodhart Collection*, London 1983.

Hughes, T., *English Domestic Needlework. 1660–1860*, Lutterworth Press, London 1961.

Huish, M. B., *Samplers and Tapestry Embroideries*, Longmans Green and Co., London 1913.

Kendrick, A. F., *English Needlework*, A. & C. Black, London 1933.

King, D., *Samplers*, HMSO, London 1963.

King, D. and Levey, S., *Embroidery in Britain from 1200 to 1750*, Victoria and Albert Museum, London 1993.

Krueger, G. A., *A Gallery of American Samplers, The Theodore H. Kaptek Collection*, New York 1978.

Meulenbelt-Nieuwburg, A., *Embroidery Motifs from Dutch Samplers*, Batsford, London, n.d.

Morris, B., *Victorian Embroidery*, Herbert Jenkins, London 1962.

Parker, R., *The Subversive Stitch. Embroidery and the Making of the Feminine*, The Women's Press, London 1984.

Proctor, M., *Victorian Canvas Work*, Batsford, London 1972.

Staniland, K., *Medieval Craftsmen. Embroiderers*, British Museum Press, London 1991.

Swain, M., *Figures on Fabric*, A. & C. Black, London 1980.

Tarrant, N., *The Royal Scottish Museum Samplers*, Edinburgh 1978.

Vinciolo, F., *Renaissance Patterns for Lace, Embroidery and Needlepoint*, Dover, New York 1971.